# Table of Contents

CASE STUDY #4
*WRITER DEIRDRE McNAMER*

CASE STUDY #19
*BUSINESS TITAN HENRY KRAVIS*

CASE STUDY #20
*DR. AARON T. BECK, FATHER OF COGNITIVE THERAPY*

CASE STUDY #27
*ACTOR JOHN MAHONEY*

CASE STUDY #29
*ACTOR ARMAND ASSANTE*

# Introduction

The purpose of this book is to share the twenty-five years of professional photographic assignments I have completed and the varied lighting challenges they have presented—from the early days of using a Vivitar flash on camera, to the more complicated lighting setup of five power packs and twelve strobe heads.

I believe there is a correlation between the fine art of cooking and the process of creating a well-crafted portrait with substance. Photographic lighting, like cooking, has "recipes." If you follow them carefully, you end up with what you expected; if you add a little extra seasoning (experience and intuition) and use your taste buds (vision), however, you may end up with a masterpiece—a true pièce de résistance.

This book is intended for any photographer who uses artificial lighting to create portraits. Whether you are a wedding photographer or celebrity photographer this book is set up to give you real lighting solutions, as well as behind-the-scenes tips that may save your reputation in a real-world photo assignment.

I have taught photography for over ten years at a variety of institutions and to hundreds of students. Through this, I have learned to listen and provide effective, comprehensible responses—even if they are not necessarily conventional. You may find my methods unorthodox, but I urge you to give them a try.

In the first section of this book, I have included a few basics of portrait lighting—simple setups, tips on some unusual lighting modifiers, and instructions for using flash to light your images. The second section of the book is divided into fifty case studies—images created during real assignments. For each of these, I have included details such as my visual objective, the equipment used, posing techniques, and a few tips that apply to the particular image. A lighting diagram also accompanies each case study, showing you exactly how the effect seen was created.

*This book is set up to give you real lighting solutions, as well as behind-the-scenes tips . . .*

In all cases, I've attempted to keep my discussions short and to the point; photographers are visual people and most of us don't enjoy digging through overly complicated explanations. (*Note:* To that end, I will also forgo any weighty discussions on what makes a great portrait, the importance of photographic history, the debate between commercial and art photography, and how big a digital image must be to match up with the resolution of film.)

My objective in this book is to demonstrate and explain to you how a professional photographer shoots and thinks. My hope is that you study the diagrams and the results, and either copy them or, better yet, improvise on them to create work with your own unique vision.

## About the Author

Drawing by Melodie Begleiter

Steven Begleiter is a freelance photographer living in Missoula, Montana. Before moving to Missoula he was a lecturer of photography at the University of Pennsylvania School of Design. He has authored three books: *Fathers and Sons, The Art of Color Infrared Photography,* and *The Portrait Book: A Guide for Photographers.* He is also a contributor to trade magazines such as *Photo Techniques* and *Rangefinder,* and has been featured in *Studio Photography.*

His professional career began in 1980 as first photo assistant to Annie Leibovitz and Mary Ellen Mark. Since then, his work has appeared in *Esquire, Big Sky Journal, Us Magazine, Forbes, Elle, Business Week,* on the cover of *Time,* in Fortune 500 annual reports, and in national advertising campaigns.

He is a recipient of a Greater Philadelphia Cultural Association grant and has served on the board of the Philadelphia Chapter of the American Society of Media Photographers. In addition to his freelance photography business, he teaches at the Rocky Mountain School of Photography.

For more information: www.begleiter.com

## Acknowledgments

I would like to thank all the people who took time out of their lives to let me take their portraits. In addition, I would like to thank the art directors, photo editors, and publishers who trusted me to deliver a creative portrait, as well as my staff, assistants, stylists and support team. I would also like to thank Steve Schwartz, of B&H Video Pro Audio, and Bill Gratton of the MAC Group US, for lending Impact and Profoto gear to play, learn from, and grow. Lastly, my wife Kate, son Makhesh, and daughter Metika, who let me disappear into the night to complete this book. Love and kisses.

## In Memory

This book is dedicated to the loving memory of John Siegrist, my second father, and Sri Chinmoy, spiritual teacher and prophet of peace.

# Lighting
# Basics

# Portrait Lighting

*B*y observing how the light changes the form of the subject's nose, chin, cheeks, and eyes, you can begin to understand what light is best for your subject. The following are some common setups.

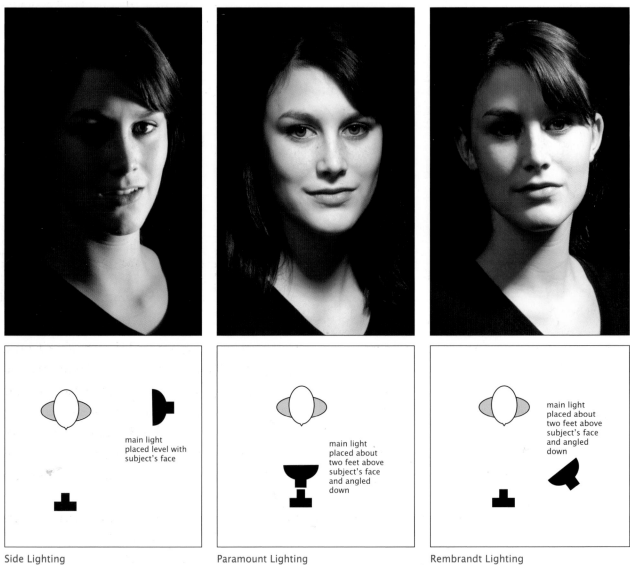

Side Lighting

main light placed level with subject's face

Paramount Lighting

main light placed about two feet above subject's face and angled down

Rembrandt Lighting

main light placed about two feet above subject's face and angled down

### Side Lighting

For this setup, the main light is placed to the side of the subject (level with the face; note the catchlight in the subject's eye on the facing page) and pointed toward their nose. The light illuminates half of the face, shadowing the other side.

### Paramount (or Butterfly) Lighting

To place a butterfly-shaped shadow under the subject's nose, the main light is placed on axis with the camera and about two feet above the subject's head. This style, popular in Hollywood in the '30s and '40s, accents the cheekbones, chin, and shape of the nose.

### Rembrandt Lighting

Rembrandt lighting is characterized by a triangular highlight on the cheek. To achieve this, the main light is placed to the side of the subject and angled down from about two feet above the subject's head. This is a classic style, but it may not be suitable for all faces.

### Variations

**Side Lighting Modified.** Adding a second light opposite the main light illuminates the shadow area, creating two highlights on the nose and on the outside edge of each eye. This setup is common in low-end portraiture; it is easy and regardless of how your subject turns, the light will basically the same.

**Rembrandt Lighting Modified.** After looking at the different effects in this series, I felt Rembrandt lighting suited Brenda's face. To soften the effect I used a Profoto three-foot Octagon softbox for the main light. I placed a silver reflector opposite the light to open up the shadow side, and added a round white reflector on the posing table to bounce light up and clean up the shadows under Brenda's chin. For more dimension, I also added a strobe on the backdrop. This was placed on a floor stand with a 30-degree grid spot and some spun glass over the grid to soften the light.

**Add a Reflector.** With any of these setups, adding a reflector on the side of the subject opposite the main light will open up the shadows, reduce the contrast and capture more detail, changing the feel of the portrait.

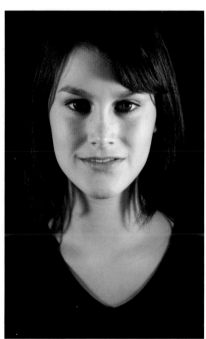

light placed
level with
subject's face

light placed
level with
subject's face

Side Lighting Modified

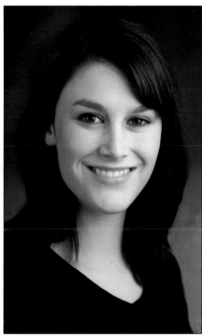

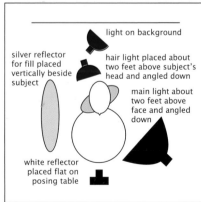

light on background

silver reflector
for fill placed
vertically beside
subject

hair light placed about
two feet above subject's
head and angled down

main light about
two feet above
face and angled
down

white reflector
placed flat on
posing table

Rembrandt Lighting Modified

# Advanced Light Modifiers

We all know about umbrellas, grids, and rectangular softboxes (if not, be sure to buy my book *The Portrait Book: A Guide for Photographers*). In addition to these everyday modifiers, there are some advanced tools that each create a specific quality of light—a quality you may find desirable and one that may even shape your style of portraiture. The following are some that have become my favorites. (Thanks to Profoto for letting me try these out!)

### Octagonal Softbox

The three-foot octagonal softbox is a nice alternative to the regular rectangular softbox. The octagonal shape wraps the light more evenly around the face, creating a softer light and less contrast when using Rembrandt lighting. (The final photograph of Brenda on page 9 was taken with an octagonal softbox.)

Octagonal Softbox

### TeleZoom Reflector

In the final portrait of Brenda on page 9, I also used a Profoto TeleZoom reflector and grid for a backlight. The TeleZoom is an oversized reflector that, in combination with the grid, produces softer lighting than a regular reflector and grid. You can also control the spread of light by sliding the reflector away from the flash, resulting in a narrower beam.

This modifier is great for use as a hair light or back light, as shown in the image of Michael and Gay at the top of the facing page. Here, the broad spread of the

TeleZoom Reflector

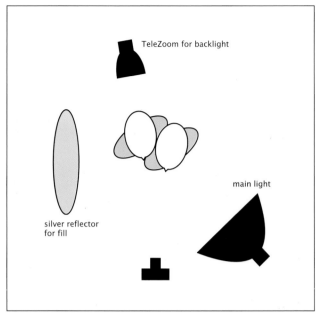

The lighting used for this image of Michael and Gay is a great basic setup that can easily be adjusted to suit the shape of the subjects. If the subject's face is round, for example, you might want to slim it by moving the reflector away from the subject to create more shadow (or you could eliminate the reflector entirely, resulting in a more dramatic image). Here, I was photographing a couple, which can make posing difficult if you are not prepared. I like to create tight, simple compositions by bringing my subjects as close to each other as comfortably possible. In this case, I placed a posing stool behind a padded piano bench set at a 45-degree angle to the camera. With Michael sitting on the stool, Gay sat on the bench and leaned back to be cradled by Michael. To close the physical gap, I had the couple get "cheek to cheek" and wrap their arms around each other. I find this technique also loosens up the subjects and results in a more playful photo session.

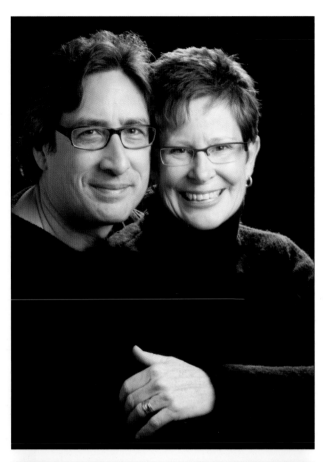

backlight helps separate the subjects, who were wearing black and photographed against a black background. A silver reflector was also placed on the left side of the subjects to bounce light back onto the shadow sides of the faces.

### The Globe

The Profoto Globe light produces a very soft but modeled quality of light. Because of its small size (around fifteen inches in diameter), round shape, and frosted Plexiglas surface, the light doesn't have the coverage of a three-foot octagon softbox, but the gentle quality of the light it produces is similar.

The best way to determine the type and placement of the main light in a portrait is to examine the sub-

Globe

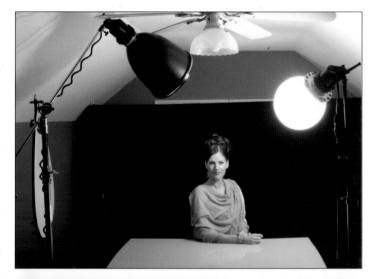

ject's eyes. The shape and placement of the catchlight (the reflection of the main light) will tell you where and what type of light the photographer used. In the inset shown with the portrait of Julie to the right, you can see a round reflection just above the pupil. This tells you the primary light source (main light) was round (like a globe light) and that the light was placed to the right of the subject and about two feet above her head.

In the setup shot at the top of this page, you can also see that I am working in a small space. This is a great application for the globe light, since there isn't much room for a large softbox. Notice that the placement of the light is similar to that used in the Rembrandt lighting setup (see page 9). Here, the triangle highlight is rounder because of the shape, size, and diffusion of the globe.

### The Beauty Dish

The beauty dish is a large, flattened reflector (36 inches in diameter), with a deflector in front of the flash tube to redirect the light into the dish. Placed close to the camera, this virtually eliminates shadows on the face. The quality of light this renders is cleaner than a softbox or globe, resulting in a commercial look. It's a great choice if your client happens to be a cosmetics company.

Like the globe light, the beauty dish creates a round catchlight. As you can see in the eye inset photo on the facing page, however, there is a black dot in the middle, caused by the de-

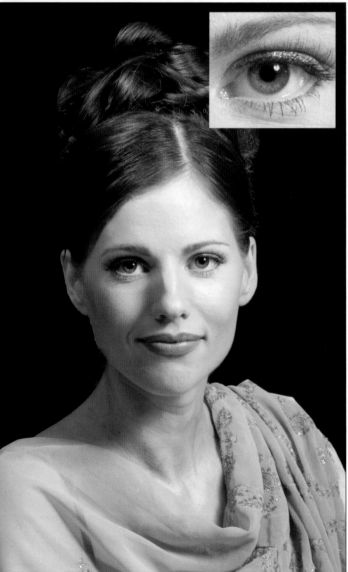

Beauty Dish

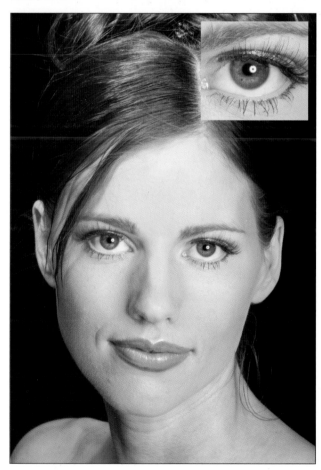

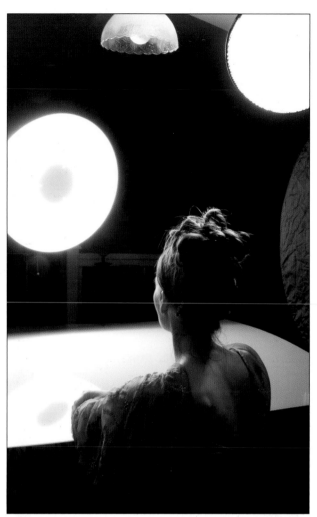

In the above image you see what the model sees—pretty daunting. In the image to the left, you see the result of this setup: the almost shadowless lighting that is popular in commercial photography. Notice how Julie extended her forehead, drew her chin in and down, then looked up with her eyes. This smoothes out the neck (in men, if there is a pronounced Adam's apple, this will soften the bump) and makes the eyes look bigger.

flector in the middle of the dish. Notice the highlight in the pupil is more centered. This tells you that the light is closer to the camera.

### The Ring Light (a.k.a. The Bug Light)

The ring light was actually designed to create a circle of flash around the lens to evenly illuminate insects and other macrophotography subjects (thus, I sometime like to call it the "bug light"). The quality of the light was so unique, though, it was quickly adapted for use in portrait and fashion photography.

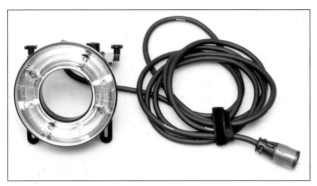

Ring Flash

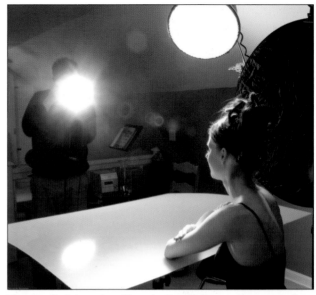

The ring flash in action, Photo by Pam Voth.

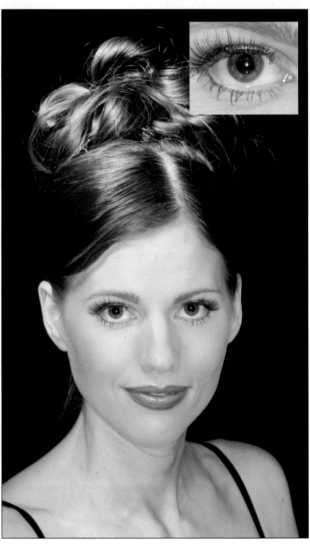

The ring light mounts directly onto the camera body using the tripod mount. Your lens goes through the center of the flash and you're off to the races. When hand-holding your camera with the ring light, it is extremely important that you and the model set your positions for accurate exposure. Any *camera* movement toward or away from the subject will also change the distance from the *light* to the subject, altering the exposure. (*Note:* The ring flash can also mount to a tripod, but in my experience this restricts your movement.)

The catchlight created by the ring light (seen in the eye inset image in the portrait of Julie to the right) is similar to that seen when using on-camera flash. The big difference is that the reflection is round and dead center in the pupil. Note, too, the dilation of the pupil.

Like light from a beauty dish, light from a ring light is shadowless. However, it is also much harder. Notice how it brings out the form in Julie's face. Since the pupils are dilated, the eyes also appear much darker.

Ultimately, the ring light is a great choice for edgier portraits and fashion since the quality of light creates a specific style. However, you must be aware that the ring light produces a powerful burst of light. If your subject is sitting in a dimly lit studio staring straight at the light, this can create eye discomfort. Be sure to warn your subject when you are ready to shoot, and give them a count. Because it is so close to the lens the ring light will also create red-eye; fortunately, this can easily be fixed by most digital imaging programs.

*A Lesson Learned*

Now that we've covered a lot of interesting equipment, I would like to end this introduction with a story about how I learned that keeping it simple is sometimes the best place to start—and that listening to your subject can save you time.

I had been working with John R. Howard Fine Art, photographing their art and architecture, and was asked to take a portrait of John for his web site. As I was mulling over how I wanted to take the portrait, I started thinking of Arnold Newman and his iconoclastic portraits of great artist in their studio. I scouted out a location in the gallery and devised a somewhat elaborate lighting setup—I even brought my 4x5 field camera to get the Newman feel.

The session went well and I liked the portrait, but my client wasn't excited about the end result. He felt he looked too stiff; he wanted to portray himself as an open and friendly person. Rather than letting my ego get in the way, I decided to listen to my client and try it again—but this time outside. He agreed and I came back the following month (John had grown a beard in the meantime). This time, I came with just my flash and 35mm digital camera. I scouted the outside property and saw that the sun would be moving behind a grove of pine trees in about an hour, which would make for a good backdrop. It was a simple setup, using the backlight for separation and a fill flash to illuminate my subject. It took about two minutes to set up and ten minutes to shoot—and it was the perfect shot for my client's needs.

The moral of the story is that sometimes, we (photographers) can get too hung up on gear and grand ideas and forget the needs of our clients.

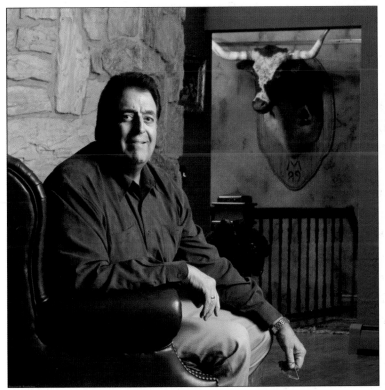 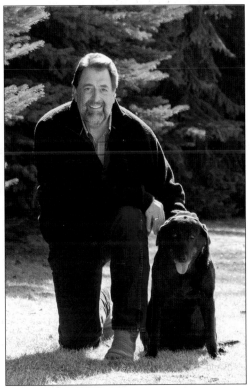

The portrait on the left, created using a complex studio lighting setup, was my first idea. I felt it was a successful portrait with a strong composition and classic pose, but it wasn't quite right for the client. The image on the right suited him better. It was shot using only on-camera flash and backlighting from the sun. I set my Canon D30 camera to the program mode, and my Canon 580EX flash was set on the ETTL mode; I increased the power of the flash to +1.

# Working with Flash

*A*lthough the sun is my favorite light source, it is often less than cooperative. It is either in the wrong part of the sky or hiding behind thick clouds. As a result, the laws of nature mean we must learn to use flash effectively. Used correctly and creatively, this economical light source will render great results.

### The Pop-Up Flash

In desperate situations I will use the pop-up flash. I say desperate, because this is the least controlled light and typically yields only adequate results. With a little finesse, the pop-up flash is sometimes better than no flash, however

**For Fill.** Both prosumer and professional cameras allow you to dial up or down the pop-up flash output. You can, of course, also increase or decrease the camera exposure. By increasing/decreasing your flash output and increasing/decreasing your camera's exposure settings, you can find a combination at which the flash balances appealingly with the ambient light.

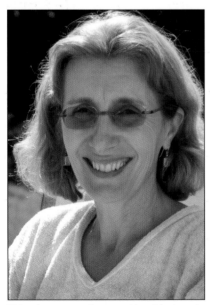  

This photo was taken outside with my subject backlit. The exposure was $1/180$ second at f/6.7 with no flash. I set my camera to the program mode and let it decide the best exposure. The result looks fine, but the back, the brightest tone in the image, takes away from my subject's face.

This image was shot at $1/250$ second at f/5.6. I kept my camera in the program mode and set my pop-up flash at +1. This means that the output of the flash will be one stop brighter than the camera exposure. The result is better than without the flash but it looks a little too artificial for my taste.

This image was shot at $1/250$ second at f/5.6 with my camera in the program mode and set my pop-up flash at –1. The flash is now one stop less than the camera exposure. To my eye, this looks more natural.

For our first sequence of images in this section (facing page), pop-up flash was used outdoors for fill light. In the first shot (facing page, left), we see the result of shooting with no flash—just sunlight. Unfortunately, the bright areas of the backlit subject distract the viewer from her face. In the second image (facing page, center), the flash was set one stop brighter than the camera exposure, resulting in an artificial look. In the final image of the series (facing page, right), the flash was set one stop under the camera exposure for a more natural and balanced look.

This image was shot at $^1/_{250}$ second at f/5.6. I kept my camera in the program mode and set my unmodified pop-up flash at +1.

This image was shot at the same camera settings, but a Gary Fong Lumisphere was placed over the flash to soften it.

**Diffusing the Pop-Up.** Diffusing your pop-up flash will result in a more flattering quality of light.

Shooting with the dome from a Gary Fong Lumisphere.

For example, consider the pair of images above. The first image (left) was photographed with my camera in the program mode and my pop-up flash powered to +1 (one stop over the camera exposure). For the second image, I placed the plastic dome from an early version of the Gary Fong Lumisphere over my pop-up flash. The frosted plastic dispersed the flash, softening the light on my subject. Although the effect is subtle, the second image is more flattering and less washed out.

To achieve the same softening effect, you can also go to an art-supply or craft store and buy some frosted vellum and Velcro. Cut the frosted vellum to cover the pop-up flash and use the Velcro to attach the vellum to your camera. (*Note:* For another cool effect, you can even place colored gels or vellum in front of your pop-up flash.)

### Auxiliary Flash

Pop-up flash definitely has its limitations. To create arresting images with artificial light you need to have more control over your light source than is possible with pop-up flash. You not only need to control the

*output* of the light, but also to decide on the *direction* and the *quality* of the light you want to achieve. The first step—and the least expensive option—is to purchase an auxiliary flash for your camera.

Teaching lighting workshops has taught me that students are often totally mystified, even intimidated, by the use of auxiliary flash. As a result, the flash either stays in the closet or is pulled out as a last resort. However, with the advanced technology in today's portable flashes, combined with the immediacy of digital photography, there is absolutely no reason to be intimidated by auxiliary flash. When photographing weddings and events, knowing how to creatively use your flash is absolutely essential, but I have even used my dedicated flash on commercial shoots as an auxiliary light. In fact, for under $1,500 you can set up a complete studio with portable, lightweight, off-/on-camera flashes.

Before I unravel the mysteries of the auxiliary flash, though, I would like to discuss why one would want to use a flash in the first place. The obvious reason is to illuminate an area that would otherwise be too dark for your camera's film or digital sensor to record. However, you should also consider using a flash when you want to lighten the shadows in an image (reducing the contrast), freeze motion, control the quality of the light, or create special effects.

**Dedicated or Non-Dedicated?** When using your flash, the first step is to determine whether your flash is dedicated to your camera—meaning that the flash and the camera talk to each other, calculating how best to achieve a good exposure.

A non-dedicated (or universal) camera flash, such as the Vivitar 285 or the Qflash T5D and X5D can, with the right adapter, work with many makes and models of cameras. However, these units need to be set up before they will communicate with the camera. The advantage of this type of flash is that it can be used with any camera model, unlike a dedicated flash that only works with cameras from the same manufacturer (for example, Canon flashes only work with Canon cameras).

**The Universal Flash.** The first step in using a universal flash is to set the ISO. If you were using 100 ISO film or an ISO setting of 100 on your digital camera, you would set the ISO on your flash to 100. By matching the camera and flash ISO, you are telling the flash how much power it will need to output in order to achieve a correct exposure.

The next step is to determine what aperture you'll shoot at and how much distance you want the flash to cover. In the days before electronic flash, this was where guide numbers (the power of the flash divided by the distance from the camera to the subject) became important. Fortunately, with the advancement of the electronic flash, guide numbers have gone the way of the slide ruler. ( *Note:* Guide numbers do, however, indicate the strength of the flash. So when shopping for your ideal flash, note the guide number; a bigger value means a more powerful flash.)

Today, most universal flashes have some type of automatic system that calculates the correct exposure. For instance, the Vivitar 285 uses a color-coded system to automate the correct exposure. Let's look at a hypothetical situation.

1. Set the ISO on your flash to match the film/digital speed. Let's say it's 400.
2. Determine the distance from the flash to the subject. Let's say it's 40 feet.
3. On the Vivitar 285, Look for the color that will cover 40 feet and set the dial to that color.
4. This dial will indicate what your aperture should be (for example, f/4).
5. The dial will also indicate the maximum distance the flash will cover.

The distance you need to cover your depth of field will determine the color you set your flash on—a little easier than figuring out the guide number!

**Sync Speed.** The shutter speed needed to synchronize your flash depends on whether your camera has a focal-plane/curtain shutter (found in the camera body), or a leaf shutter (found in the lens itself). Leaf shutters allow you to sync at the fastest available shutter speed—up to $\frac{1}{500}$ second. Most curtain shutters, the kind found in 35mm cameras, allow you to sync your flash at speeds up to $\frac{1}{125}$ second. (*Note:* Nikon and Canon, however, manufacture some models that sync at up to $\frac{1}{250}$ second.)

This is important to know, because if you set your shutter speed *faster* than the recommended sync speed, the flash will only illuminate part of your frame. This occurs because the distance between the shutter curtains as they move across the film plane is so narrow and the duration of the flash is so short, that the light from the flash doesn't have time to illuminate the entire frame.

**Dragging the Shutter.** Although you are limited to how fast you can set your shutter to sync with the flash, you are not limited to how *slow* you can set your shutter speed. Using a shutter speed that is slower than the recommended sync speed is called dragging the shutter. This is a useful technique in situations where you want to combine ambient light with flash.

For example, imagine that you are photographing a 20x60-foot room that is illuminated by some window light. The ambient light in the room is f/11 at $\frac{1}{15}$ second. Now, in walks the basketball team you have been hired to photograph. You know your flash can only illuminate up to 20 feet with an aperture at f/11. This will be fine for properly exposing the team, but if you set your shutter at $\frac{1}{60}$ second at f/11, it will look like the team is standing in a cave; the flash will illuminate the first 20 feet of the room, but the other 40 feet will be two stops underexposed. The solution? Drag the shutter. By slowing down the shutter to $\frac{1}{60}$ second, you'll enable the ambient light to record sufficiently that it matches the flash output. The result will be a more natural-looking environment. Just re-

It is essential to know how to work your flash outdoors, especially if you plan to shoot weddings. At Hal and Shelby's wedding, for example, fill flash saved the day. The ceremony had just ended and the formal portraits were just about to start—but it was around 3PM on a bright, sunny day. This created very deep shadows that are not ideal for wedding portraits. The key was to turn my subjects away from the sun so they were backlit (or, in this case, closer to side lit). This created highlights to help separate them from the background, but caused deep shadows on their faces. With my flash on the hot shoe, I attached a Gary Fong Whale Tail diffuser, put my camera in the program mode, and powered down my flash to $-\frac{1}{2}$. With my focus on auto, the only thing left for me to do was to engage with my subjects and shoot until I got the right expressions. Wow—that was easy!

member to use a tripod when shooting at $\frac{1}{15}$ second or slower.

**Using the Flash Outside.** Earlier, I mentioned how the flash can be used to lighten shadows and reduce contrast in a portrait. The key to achieving good

exposure outside with a flash is first determining the level of the ambient light. Let's say you've been hired to photograph a portrait between noon and one o'clock—the worst hour for an outdoor portrait. It is a very sunny day, and when you look through your viewfinder you see hard shadows on your subject's face. According to your spot meter, at $\frac{1}{125}$ second the shadows measure $f/4$, while the highlights measure $f/11$. Simply by setting your flash to illuminate your subject at $f/8$ at $\frac{1}{125}$ second, you can reduce the contrast by two stops and create a more flattering, natural-looking portrait.

**Freezing Action.** In 1931, Harold Edgerton took the on-camera flash one step further with his invention of the stroboscope. His intention was to take high-speed photographs of familiar subjects, such as a splattering droplet of milk—things that move at speeds beyond the ability of the human eye to perceive. That same technology is what allows you to freeze action with today's flash units.

One reason to use flash is for its ability to freeze action.

**Direct or Bounce Flash.** On-camera flashes can create two types of light: direct or bounced.

Direct light is produced when the flash is aimed at your subject. This is the harshest type of lighting—and if the light is too close to the lens, red-eye will appear in your portrait. Direct flash does, however, take full advantage of the power of the flash, maximizing the light that falls on your subject.

Bounce (or indirect) flash is produced when the flash is angled in such a way that the light bounces off a surface before hitting the subject. This is an easy and effective way to produce a softer quality of light with your flash. Because you are redirecting the light and it must travel farther to illuminate your subject, however, there will be at least some loss of light intensity when bouncing the flash.

Indoors, you can angle your flash up and bounce the light off the ceiling. Just make sure the ceiling is either white or gray; otherwise a color cast will reflect onto your subject. I find fifteen-foot ceilings to be of an adequate height for proper exposure.

When working outdoors, more advanced flash models have a built-in bounce card that you can pull out when needed. Additionally, manufacturers like Lu-

miquest sell all types of bounce-flash accessories. You can even place a white index card on top of your flash to create a surface that will redirect the flash.

**Special Effects with Flash.** Edgerton's experiments with flash were not only to freeze action but also to capture a series of images of a single motion, a practice called stroboscopic photography. To do this, you must work in a totally dark room with your camera set on bulb. Then, with the shutter open, you can pop your flash multiple times and record the stages of a single motion. Advanced flashes have a multiflash function that makes this easier to accomplish.

As noted earlier in this section, you can also place colored gels over your flash to create surreal lighting effects. Just remember that some gels absorb light; to compensate, you may have to increase your exposure. If you have a light meter, you can take measurements with the filter on the flash and off the flash to see just how much light is being lost.

It is also possible to use light-painting techniques with flash—meaning you can use one flash to illuminate your subject and the entire environment. To do this, place your camera on a tripod and set the shutter on bulb using either a locking cable release or a remote shutter release. Then, set the flash to illuminate your subject and the walls at a specific distance and a specific f-stop. Trigger the shutter to begin the exposure and start popping the flash to illuminate the subject and then the walls. Ask your subject to stay very still and avoid directing the flash back toward the camera (it is also a good idea to wear black to make sure you yourself don't show up in the photo). When you have covered the entire area with flash pops, release the shutter to end the exposure.

**Taking the Flash Off the Camera.** One easy way to control the quality of the light from your flash is to take your flash off the hot shoe. This can be done using either a flash cord or a remote.

If you decide to use a flash cord, one end of the cord attaches to the flash and the other attaches to your camera's hot shoe or PC socket. This allows you to move the flash away from the lens axis, either holding it in your hand or attaching it to your camera via a bracket (an arm-like device that supports the flash at a distance above or to the side of the camera).

If you have a larger budget (around $200) and are working with Canon flashes, you may want to look into a ST-E2 remote system. These transmitters have a range of 30 to 40 feet indoors and 20 to 30 feet outdoors. They can also trigger an unlimited number of Canon flashes, offering many creative possibilities.

One advantage of taking your flash off the camera is the elimination of red eye. Red eye is caused when light from a flash enters your subject's eyes at an angle of less than 2.5 degrees. When this happens, the flash reflects off the retina and back into the camera lens. Moving the flash off axis with the lens solves this prob-

While the shutter remains open, multiple flash pops create a stroboscopic effect.

I had Melika rest her head on a lacquered table in the dining room, then placed a tungsten conversion gel over my flash along with a diffuser. I set my white balance to tungsten light to match the color temperature of the flash. The reason for all this hoopla was to get a blue background and a blue reflection on the table and still maintain realistic flesh tones. I then attached my flash to a flash cord so I could extend it over my head and direct it toward my subject. This way, I avoided a flash reflection in the window behind her and achieved a more sculpted quality of light.

lem ( *Note:* There are also digital fixes for red-eye, but if you are editing a job from a wedding or event you may spend hours fixing all those red eyes!)

**What's Right for You?**
Although many flashes are available your choices are few: either you decide to buy into your system and get the flash that was "made for your camera," or you buy a system that may be more versatile, with options of adapting it to your system. The decision should be based on your usage. If you are a wedding/event photographer, you need the best flash you can afford.

Look for a flash with a good guide number (130 feet or more). Manufacturers often combine the range of the flash with the focal lengths of a lens. For instance the guide number may be listed as "Guide No. 125ft./38m at 35mm"—as with the Nikon SB-800.

Look for a flash that is dedicated to your camera and has TTL (through the lens) capability. This allows the flash and camera to talk to each other to determine the right exposure. It's also nice to have a versatile flash head that rotates and angles easily to create bounce-flash lighting. Also, you'll probably enjoy a unit with a remote-flash function. This allows you to synchronize two or more flashes.

At this writing, flashes with all those functions cost $350–$450. In addition, you may want to consider a flash bracket ($50–$150) and a rechargeable battery (such as the Quantum at $200–$500) to power your flash. If you are purchasing the flash for personal rather than professional use, however, you can consider a less expensive flash with fewer functions. The Canon Speedlight 220 EX is a very compact flash for Canon cameras that has the TTL function but not a bounce head. The Sunpak Auto355 also has TTL and a bounce head and can be used on different makes of cameras. Both models cost less than $50.

The key to mastering flash is practice, practice, and more practice. It may seem like a burden to carry an additional piece of equipment—but it's nothing compared to the heartache of not getting the shot because there wasn't enough light or the scene had too much contrast. If you are shooting digital, there's really no excuse: you can get instant visual feedback on your LCD screen and use it to hone your skills. So dust off your flash and start creating.

# Lighting
# Case
# Studies

# Brideshead Revisited

**CAMERA:** Canon D30
**LENS:** Canon 24–105mm L series at 45mm
**EXPOSURE:** f/9.5 at $\frac{1}{30}$ second
**ISO:** 400
**LIGHTING:** Canon 580EX on hot shoe with a flash diffuser. Flash set on normal.

### Assignment

This photograph was taken during the preparation for the wedding. I like to photograph weddings in a photojournalistic style, so I begin my wedding-day coverage by being present to document all the preparations the bride and groom go through to get ready for the ceremony.

### My Visual Objective

I like to capture what I call the "quiet moments" of wedding preparation. Here, the bride, Shelby, was entering the cabin to greet her family. In my mind's eye, I had noted the frame of the door and thought it would make a nice framing element for my subject.

### Posing Technique

No direction was used in this photo since I was trying to capture a real moment. I simply watched and waited for the right moment. When Shelby lifted her train with her left arm I knew that was the shot. The pose reminded me of the goddesses depicted on the sides of ancient Greek vases.

### Story Behind the Photograph

I met Shelby at a Chamber of Commerce meeting. She told me that she was getting married and asked if I knew any wedding photographers. You never know when you may find your next client. I met with her and her fiancé, Hal, and a couple of weeks later they called me back to let me know they wanted to hire me for their wedding.

The day of the wedding, my assistant (and second shooter) arrived at the site around 1PM to scout the location and begin shooting the wedding preparations. My assistant covered the groom getting ready, while I covered the bride.

### Tips

I try to use natural light whenever I can, then supplement it as needed with flash. Here, I knew there was about a four-stop difference between the inside of the cabin and the outside. I set my camera on shutter-priority, slowing my shutter down to $\frac{1}{30}$ second to "blow out" the background. This added to dreamy quality of the image.

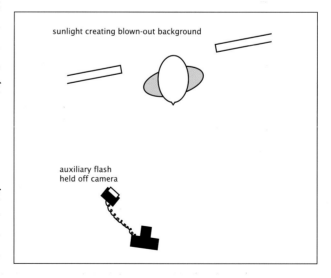

# Avoiding a Storm

**CAMERA:** Canon D30
**LENS:** Canon 24–105mm L series at 105mm
**EXPOSURE:** f/19 at ¹/₁₆₀ second
**ISO:** 100
**LIGHTING:** Profoto 1200ws pack with softbox for main light; silver reflector disc for fill

### Assignment

This portrait was used on the cover of a trade magazine called *State Ways*. The designer, from New York City, had searched the web for a photographer in Montana and saw my work on my web site. I had never seen the publication, so the designer sent samples of their favorite covers for me to emulate. The one demand was that the portrait be taken outside.

### Visual Objective

My subject, Shauna Helfert, was the Administrator of the Montana Liquor Control Division, so the state capitol with the mountains in the background was a perfect setting for the cover.

### Posing

Shauna is a state administrator and I wanted her to appear strong and confident. Because she was sitting on a narrow ledge, the challenge was having her keep her back straight, relax her left hand on top of her right, sit in a three-quarter view to the camera, and keep breathing. You would be surprised how some people hold their breath while they are being photographed.

### The Story

When my assistant and I drove to Helena early in the morning it was sunny, so I decided to photograph the inside shots first—thinking that later afternoon light would work well for the cover. After the last indoor shot, however, we went outside and found it was pouring rain. Knowing that my client needed an outdoor shot, we headed up the hills looking for a vantage point with the state capital in the background. There, I noticed a home under construction. After securing the owners' permission to shoot, I located a narrow ledge on the outdoor porch that faced the capital. At this point the rain had stopped and the skies were clearing. To compress all the elements, I selected a telephoto lens (which meant I had to shoot through a window while standing in their deconstructed living room—the photo gods were definitely looking over me that day!).

### Tips

When balancing strobe and daylight I always bracket my shutter speeds to vary the background exposure.

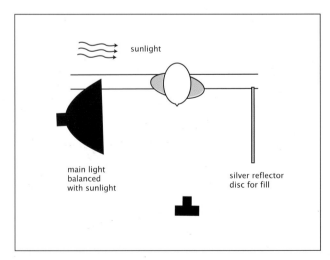

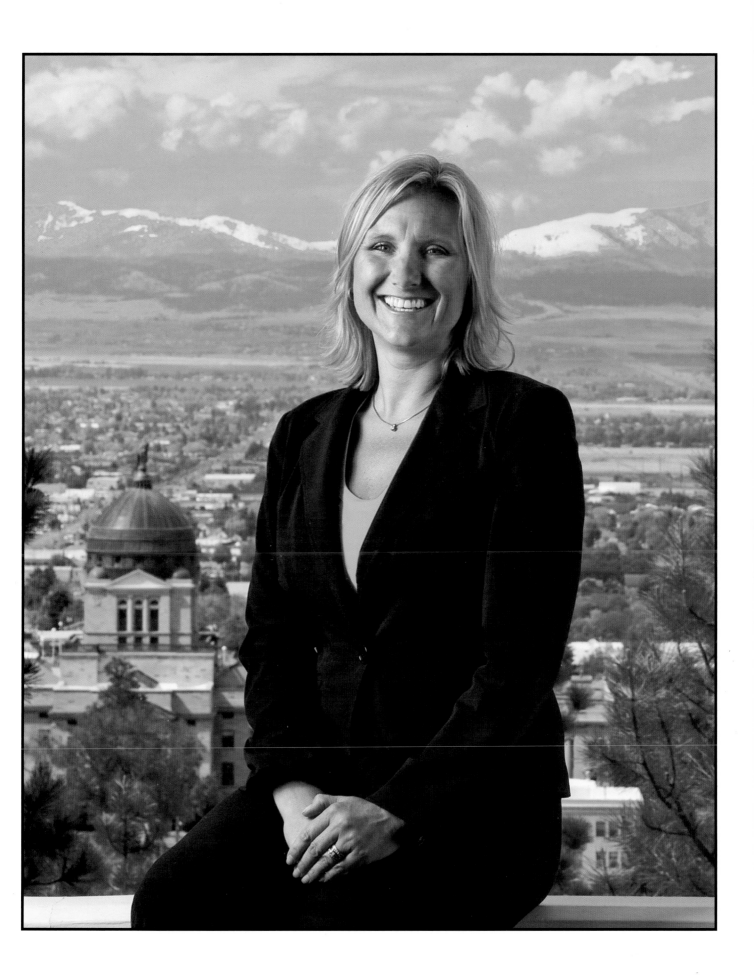

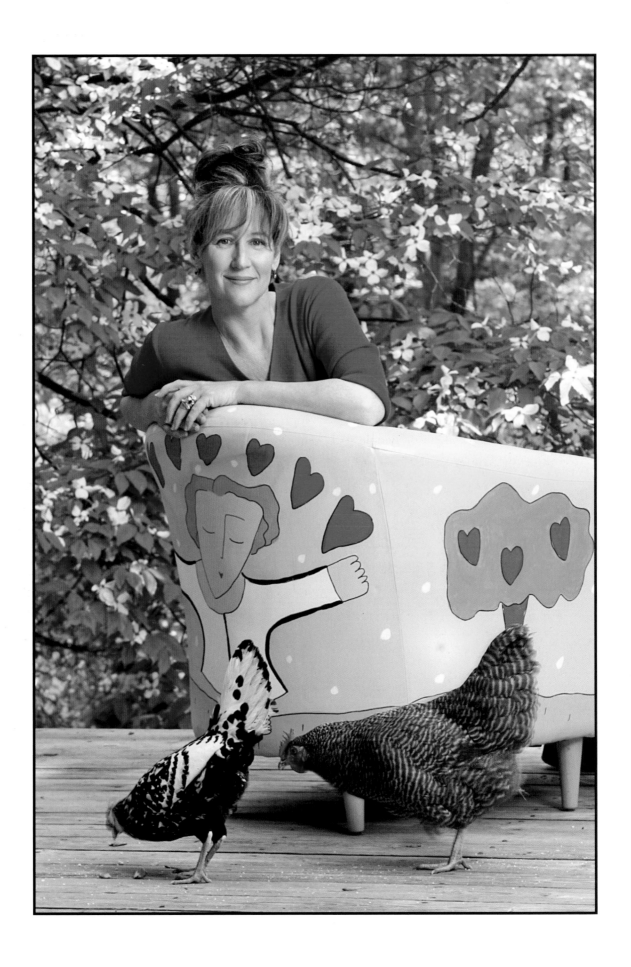

# Two Hens and a Big Heart

**CAMERA:** Canon 20D
**LENS:** Canon 28–135mm at 80mm
**EXPOSURE:** f/8 at $\frac{1}{40}$ second
**LIGHTING:** Profoto 1200ws with medium rectangular softbox and Pocket Wizards to fire the strobe

### Assignment

This was an assignment for the magazine *Inspire Your World*. (Unfortunately the publication only lasted five issues and this was the last issue.) I was hired to photograph the artist, author, and art therapist, Sandra Magsamen at her home just outside of Baltimore.

### Visual Objective

The publication was all about altruistic people so I wanted to capture a warm and spirited portrait of Sandra. When we arrived at her home, I scouted around for a location that would suit my subject. She had a great art studio where she worked, but I wanted to establish the opening shot for the article. I had seen this great chair that she created, and the porch outside her studio made for a great backdrop.

### Posing

I knew she would feel comfortable in her chair, so the pose would fit the chair. My only concern was working with her hands. Because she was an artist, I wanted her hands to show off well, so I simply told her to hug the back of the chair with her hands.

### The Story

Meeting Sandra was truly a rich experience. She is as big as the hearts she creates. When she told me she had hens on her farm I asked if we could use them for the shoot. The trick was to get the hens to do what I wanted—no easy task. Like all animals, food is a great incentive for hens, though. So I set up the shot, stood behind my camera, and directed Sandra while my assistant threw feed on the ground. It took many tries, but we finally got the shot.

### Tips

Normally I would be fussier about my subject's hair but after meeting with Sandra, I knew she liked to have her bangs fall over her forehead. This is part of her personality, and I feel it is important to identify the unique physical qualities of your subject and allow them to become part of the portrait. Similarly, choosing the wardrobe of your subject is also very important. I selected the red shirt for Sandra because I knew the color red would stand out from the green background and complement the red hearts on the chair.

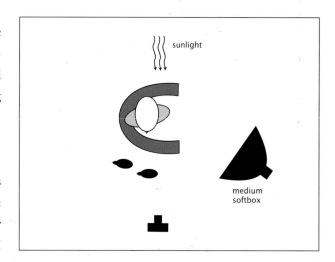

CASE STUDY #4

# Writer's Black

**CAMERA:** Canon D30
**LENS:** Canon EF 24–105mm at 67mm
**EXPOSURE:** f/16 at $\frac{1}{125}$ second
**LIGHTING:** Profoto 1200ws strobe with Profoto 3-foot octagonal softbox

### Assignment

The portrait of the author Deirdre McNamer was taken for the magazine *Distinctly Montana*. Deirdre was coming out with her fourth novel and the magazine was writing a profile on her.

### Visual Objective

Deirdre is known as a "Montana Writer"; she writes about Montana and the (fictional) people who live here. I wanted to visually incorporate that geographic essence of her books, so I felt it was important to have mountains as a backdrop. In addition, I wanted to move away from the stereotypical "western wear." Fortunately, Deirdre dressed in designer black. The lime green coffee cup was for a splash of color.

### Posing

After scouting the location, I found a comfortable patio chair and a table. I had originally placed a laptop on the table and was going to have her pretend she was working on her next book, but it looked awkward. Instead, I opted for a pen and paper—the "old fashioned" writing props. I prompted her to breathe deeply a couple times and gaze into the lens.

### The Story

I was fortunate to meet with Deirdre before I actually photographed her. This gave me an opportunity to learn a little about her and see where she lived. I planned out four different images for the article while I was there. As a bonus, Deirdre also gave me an advance copy of her novel to read. It was early spring and I wanted to wait until there was more foliage on the trees, so we planned a session three weeks later. By the time I met her again for the session, I had finished her novel and felt like I knew her a little better—and she felt very comfortable around me. As a result, the session went very well and pretty quickly.

### Tips

The key to this session was preparation, but I did have back-up plan just in case the weather didn't hold up. It was touch and go with the heavy clouds, but the weather gods were with me again. If you plan for the worst-case scenario, you will always be prepared to come away with a successful portrait.

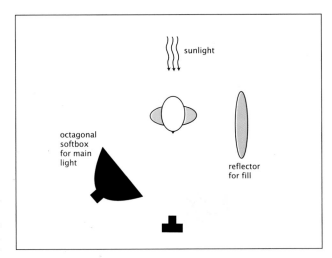

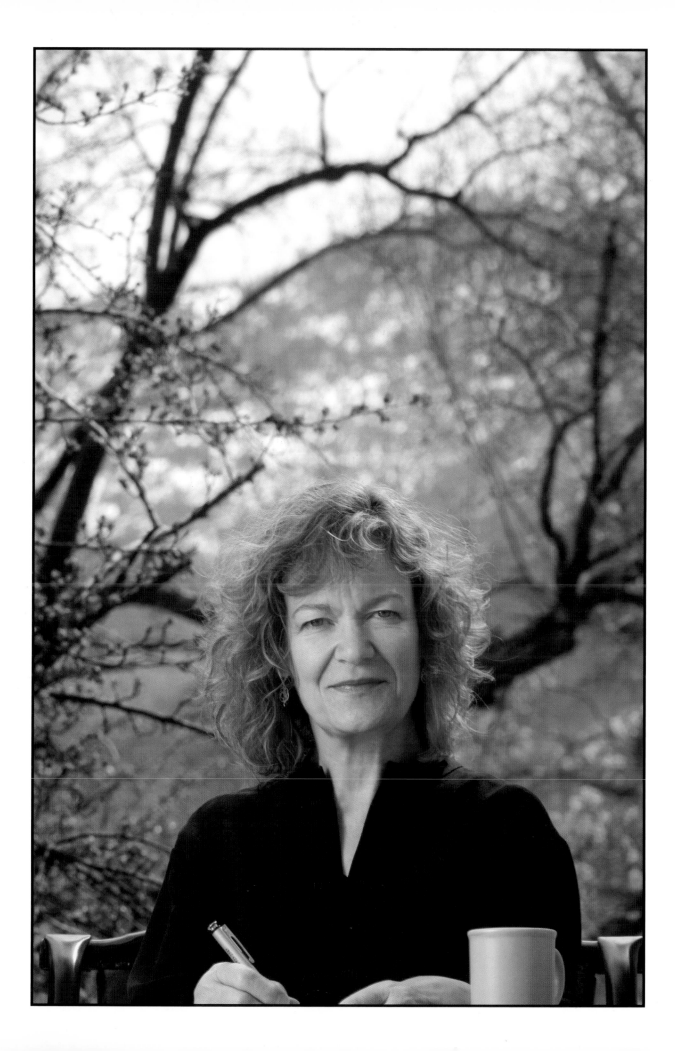

# A Cold Night in Philly

**CAMERA:** Hasselblad 503c
**LENS:** 120mm macro
**FILM:** Kodak EPP
**EXPOSURE:** f/8 at 1 second
**LIGHTING:** Hensel 1200ws power pack with Wafer 100 softbox
**OTHER:** flash lights, blankets, mirror, tripod, and cable release

### Assignment

This was a publicity photograph for a play, *Rose Selavy Takes a Lover in Philadelphia,* by Whit McLaughlin. It promoted the play for the Philadelphia Fringe festival. (*Note: Rose Selavy* was a 1920s portrait taken by Man Ray in collaboration with Marcel Duchamp; likewise, this image was a collaborative effort.)

### Visual Objective

Before the shoot, Whit gave me a general idea of what the play was about. We agreed it was important to have the Philadelphia skyline in the background and a night shot was essential to create the drama.

### Posing

In theatrical publicity photography, I find that exaggerated gestures work best. I wanted Mary look vulnerable, so I used a fetal position. Aaron was there to protect and comfort Mary, so he sat up looking directly into the lens while gently stroking Mary's hair.

### The Story

When working with a theater group, you can expect plenty of volunteers to help transport equipment. For this shoot, we picked the warmest night in March (around 40 degrees), and shot on the University Avenue Bridge over the Schuylkill river in downtown Philadelphia. We set up the lights and chairs, then I shot some test Polaroids before Mary and Aaron came onto the set. I shot about three rolls and called it a rap. The models were getting too cold to stay out any longer—and I had the shot. (*Note:* I also brought extra batteries for my strobe; they drain faster in the cold.)

### Tips

For nighttime shots, bring a good flashlight so you can see what you're doing (and as a focus-assist light on your subjects). In addition, you should know how to lock up your camera mirror to avoid vibration—and don't forget your cable release. If you do, shoot using the self-timer so you are not touching the camera during the exposure. Since I was working on a bridge and doing a long exposure, I also brought a five-pound weight to steady my tripod—and we waited to shoot until there wasn't any traffic.

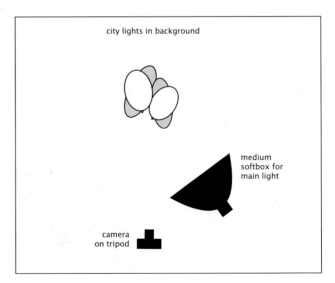

city lights in background

medium
softbox for
main light

camera
on tripod

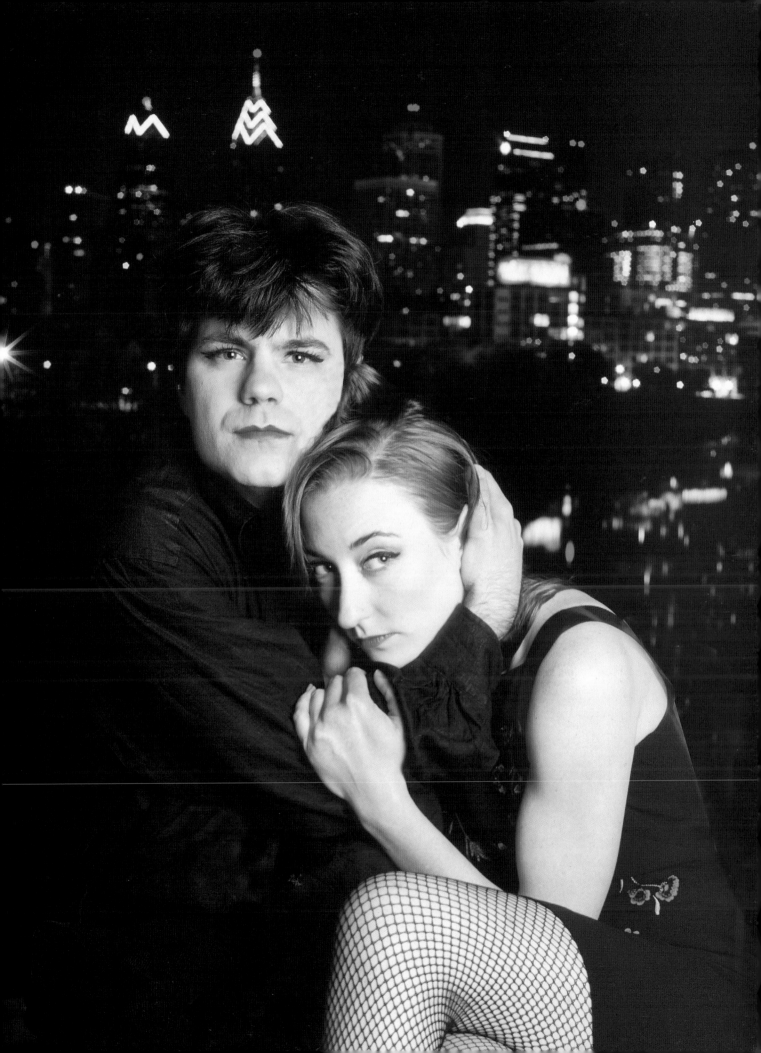

# Rudolf and Owen

**CAMERA:** Hasselblad 503c
**LENS:** 50mm
**FILM:** Kodak Plus X
**EXPOSURE:** f/16 at ¹/₁₂₅ second
**LIGHTING:** Luz 1200 power pack (no longer available) with medium Chimera softbox

### Assignment

This image of sculptor Rudolf Serra and his son Owen was taken for my first book, *Fathers and Sons* (Abbeville Press, 1989) and later licensed to an ad agency for an American Express ad.

### Visual Objective

This image fell into place when I entered Rudolf's studio/home in Manhattan. I always think of sculptors as big kids who still like to play in the mud and create wonderfully unique objects. My objective was to create a spirited, playful image of a father and son.

### Posing

This was an easy one. I asked if Rudolf could get on the floor, on the same level as his son, and give the boy some squeezes. I also liked his tennis shoes so I had him put his feet out so I could see the soles of his shoes. This look was exaggerated by the selection of a wide-angle lens.

### The Story

Anytime I photograph artists, I find the session fun and creative; they understand the process and are willing to try just about anything. It is a real collaboration. This image was taken at the beginning of my *Fathers and Sons* project, when I was trying to find at least five artists and their sons to photograph. I had gotten Rudolf's name from a fellow artist in Soho.

Like virtually all of the fathers I approached to be photographed with their sons, he said yes.

### Tips

When shooting environmental portraits remain conscious of the place where you are working. There are always visual clues about the person you are photographing. Ask questions and try to involve the person in the creative process. It builds trust and helps them feel more comfortable in front of the camera. That said, you must still remember that you are the director during the photo shoot; your subjects will respond better when you give them direction.

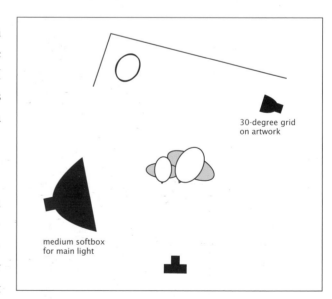

30-degree grid
on artwork

medium softbox
for main light

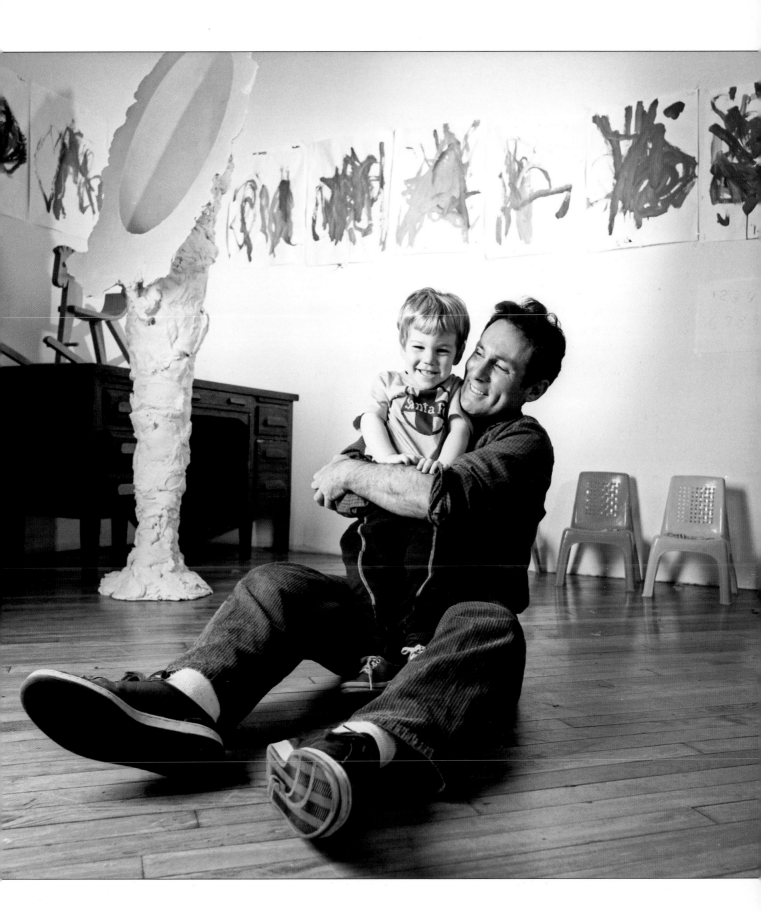

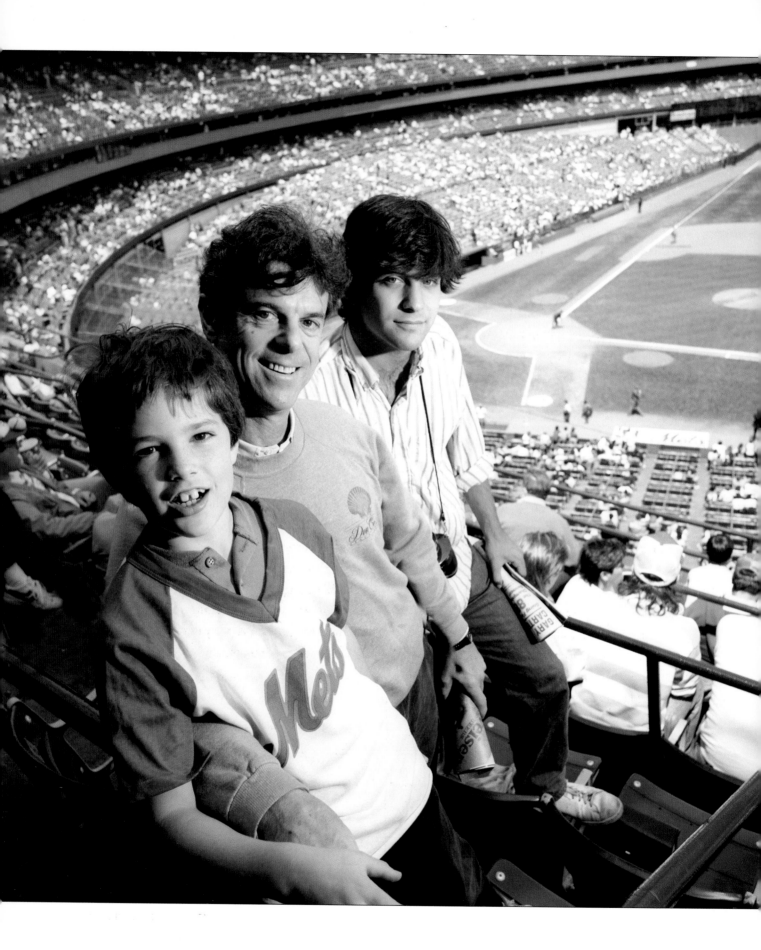

# Take Me Out to the Ballpark

CAMERA: Hasselblad 503c

LENS: 50mm

FILM: Kodak Plus X

EXPOSURE: f/8 at 1/60 second

LIGHTING: Norman 200B portable strobe bounced into an 8-inch white umbrella

## Assignment

As you might have guessed, this is also part of my "Fathers and Sons" project. Peter Davis, documentary filmmaker and writer, posed for me with his sons Jesse and Nicholas at Shea Stadium.

## Visual Objective

In environmental portraits, I am always looking for geometrical shapes and lines. Here, the long curve created by the stadium wall and the baselines converging toward home plate draw your eye to the family. To make the subjects stand out from the crowd I lit them with a portable strobe light.

## Posing

I wanted to show the sense of place, so I had them turn away from the field and lean toward the camera. I also had Jesse (in the foreground) place his hand on his father's hand to connect the two. I had Peter and Nicholas hold programs to give them something to do with their hands and build on the sense of place.

## The Story

Before the shoot, we talked about locations and agreed that going to Shea Stadium would not only be fun but appropriate for the subject matter.

Normally, I try to get permission before shooting on location, but the Mets organization is so big and guarded that I decided to just go as fan and see what happened. This is way before security got "tough," and even though I had a case with lights, a light stand and a camera case, the ticket taker just took my ticket. New York City is so media saturated that setting up a mini studio in the stands of a major-league ballpark drew no attention. Since we shot before the game started everyone left us alone. In today's security climate, I don't think we could pull it off, though.

## Tips

Whenever you shoot in a public location it is a good idea to get permission. There is always the fear of a liability by the property owner if someone should get hurt. (On that note, it is also important to have good commercial photography insurance that will cover *you* in case of an accident or potential lawsuit.) Also, be sure to carry model and property releases if you intend to sell your images commercially.

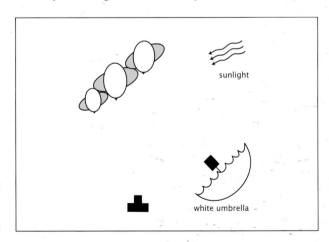

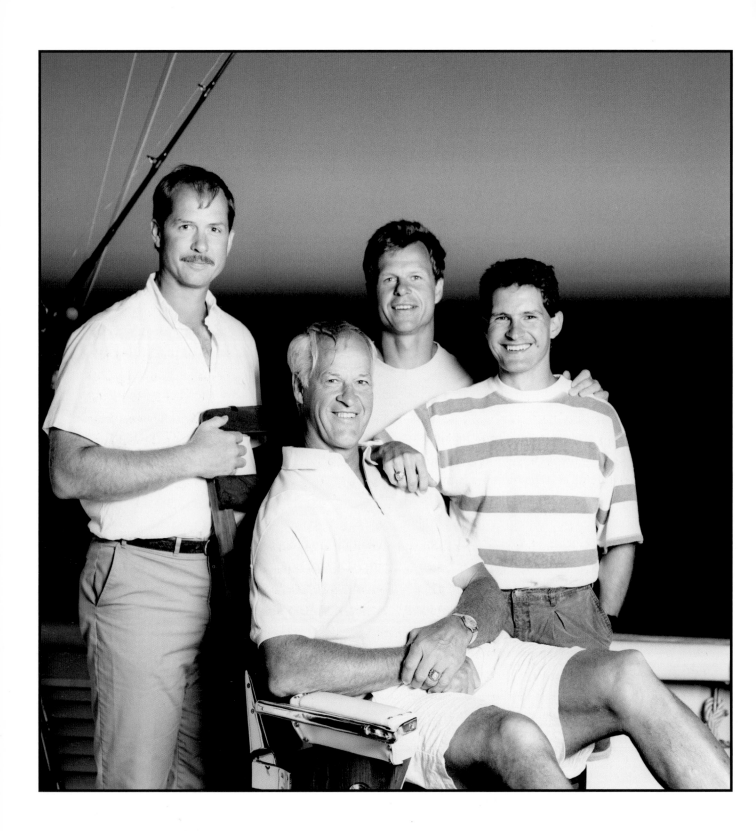

# Hockey on the Sea

**CAMERA:** Hasselblad 503c
**LENS:** 120mm macro
**FILM:** Kodak Plus X
**EXPOSURE:** f/8 at $\frac{1}{15}$ second
**LIGHTING:** Luz 1200 pack with medium Chimera light bank
**OTHER:** Gitzo tripod

### Assignment

For my "Fathers and Sons" project, I contacted Gordie Howe. He and his sons agreed to a session on their boat in the New Jersey shore.

### Visual Objective

Gordie and all but one of his sons were professional hockey players, but I wanted to capture them away from the ice. I wanted a clean background with just a suggestion of the environment—the fishing rod.

### Posing

Group portraits always pose logistical challenges. Since this photograph is about the patriarch, I placed Gordie in the center, surrounded by his sons. The fishing chair presented the perfect way to accomplish this. Once I placed Gordie in the chair I arranged his sons. Marty held the top of the chair, Mark placed his left hand on Murray's shoulder, and Murray placed his right hand on Gordie's shoulder. This created a visual flow of hands that leads to Gordie's face. I had Gordie rest his hands on his lap, anchoring the group.

### The Story

Not knowing what to expect, I brought all my equipment to the family's condo on the ocean. When they mentioned that they had caught some fish early that morning, a light bulb went off: I realized I had to photograph them on the boat at dusk.

My assistant and I set up in about an hour, worked out who should be where, and did several test shots before bringing the family to the boat. At that point, I knew I had only about twenty minutes of good background light. Because of my preparation, though, this was more than enough time. The Howes liked the short session and seemed to have fun. (The real treat was when they asked my assistant and I to have dinner with them. They were cooking up the fish they had caught that morning—and it was a great meal.)

### Tips

Extension cords were key to this successful shoot. I didn't own a portable pack at the time, so I ran a 100-foot extension cord from the boat to the outlet on the dock. Today I still travel with extension cords, giving me an option if my portable pack dies (provided there is an outlet nearby).

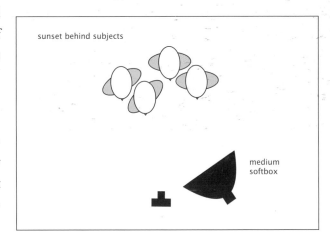

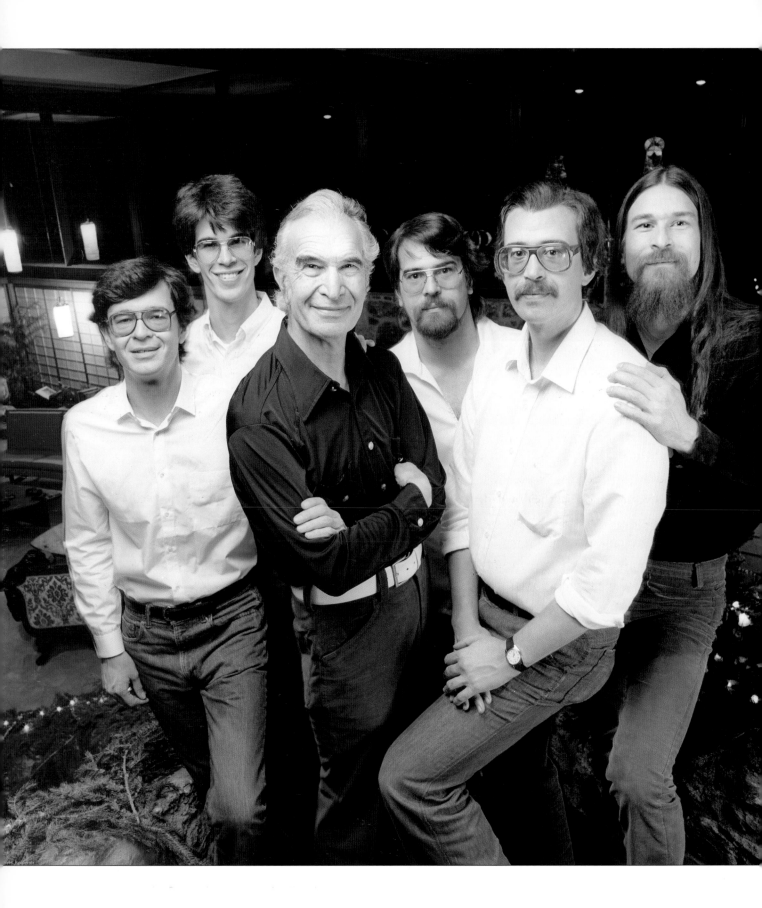

# Take Five

**CAMERA:** Hasselblad 503c
**LENS:** 50mm
**FILM:** Kodak Plus X
**EXPOSURE:** f/11 at 1/8 second
**LIGHTING:** large Chimera light bank
**OTHER:** tripod

### Assignment

If you haven't figured it out yet, working on a personal portrait project allows you the opportunity to meet your heroes. For my "Fathers and Sons" project, I had photographed Alan Arkin. He was friends with jazz musician Dave Brubeck and suggested I contact him for the book. Score!

### Visual Objective

Capturing the family dynamics is always one of my visual objectives; each son has their own identity and relationship to their father. In truth, though, the portrait is as much about me as it is about the Brubecks. Once I was happy with the placement, I would "let the camera roll" and try and capture their dynamic.

### Posing

When I arrived at their home, I noticed that Dave and his son Daniel were wearing black shirts. That started me thinking about a keyboard—black keys surrounded by white keys. This concept, although not obvious, was the driving force of my placement of the family. (It also helped that Dave was wearing a white belt.)

I also used the steps behind the family to stagger their heights. Then, I had them bend their knees to create a more casual look. The final touch was hand placement—and the key was having Dave crossing his arms. This set the tone for the rest of the portrait's family dynamic.

### The Story

The only time Dave and his family were all free and in the same place was a week before Christmas. Fortunately, Dave only lives a couple of hours north of New York City and I was free that day. By the time I got there with my assistant, Jo Caress, it was dark and the home was filled with holiday lights. It was very festive and the Brubecks were gracious hosts.

### Tips

When photographing a large group you need a large light modifier. Because four of the sons wore glasses, I used a boom stand to raise the light about three feet above the subjects to avoid causing reflections.

To capture the ambiance of a large room, try dragging the shutter, as I did here. Once you focus, turn off the modeling light to avoid recording subject movement, unless that is the effect you want.

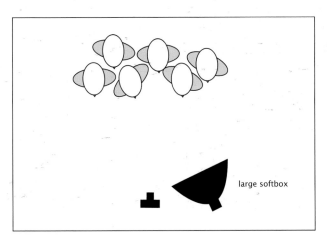

large softbox

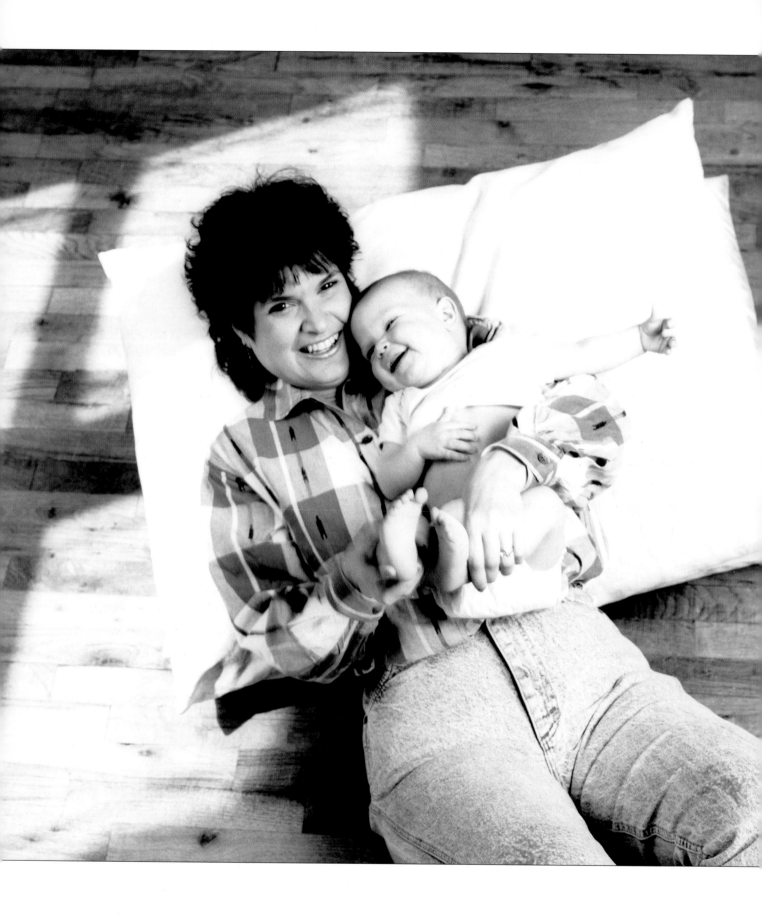

# "But Soft, What Light Through Yonder Window Breaks?"

**CAMERA:** Hasselblad 503c
**LENS:** 80mm
**FILM:** Kodak Plus X
**EXPOSURE:** f/5.6 at ¹⁄₆₀ second
**LIGHTING:** beauty dish with grid; two gobos
**OTHER:** ladder (for elevated camera angle)

### Assignment

This is actually my sister Lisa and my seven-month-old niece Ali. They had come to New York City to visit me and see my studio—and whenever family comes to visit, I make sure to make time to photograph them. (*Note:* If you decide to pursue portrait photography, photographing your family is a great place to start.) When photographing a mother and daughter, you could go in many directions. I decided to be creative and use natural light—sort of. (This is, of course, hinted at by the title of this case study, a quote from Shakespeare's *Romeo and Juliet.*)

### Visual Objective

While I was waiting for Lisa and Ali to arrive at my studio I started to notice the light patterns forming on the floor—the shapes looked like pillows. When my subjects arrived, I immediately went into action. I set down some pillows on the floor and metered, then asked them to lie down on the pillows so I could start shooting before the natural light changed.

### Posing Technique

This pose was created around the window light. I set down the pillows to mirror the window highlights. The two pillows propped Lisa up comfortably and made it easy for her to hold the baby. It is always a challenge to photograph a baby, but being able to place the infant in the mother's arms will make your job much easier. You should also have in mind some strategies to engage the baby—unusual sounds (not too scary, though) often work well. Then, be patient and ready to catch the fleeting moment when it occurs. In this instance it was Lisa tickling her feet that made the moment.

### Tips

This was a more difficult lighting situation than you might expect. To maintain the look of the highlights on the floor I had to keep the strobe light from washing them out. To do this, I used a beauty dish with a grid and a gobo to block the light from the floor.

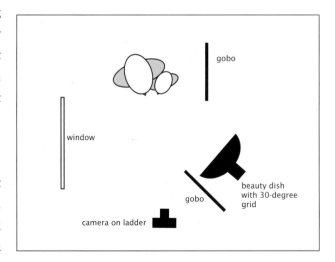

CASE STUDY #11

# Puff the Magic Dragon

**CAMERA:** Hasselblad 503c
**LENS:** 120mm macro
**FILM:** Kodak Plus X
**EXPOSURE:** f/8 at ¹/₁₅ second
**LIGHTING:** Luz 800ws power pack with one head and a medium softbox; additional light with grid on background

### Assignment

Photographing musicians has always been a large part of my personal work, and Peter Yarrow (of Peter and Paul and Mary) was on my list. Like his music and social convictions, Peter and his son Christopher, were very tender and intense to photograph.

### Visual Objective

Walking into Peter's Manhattan apartment was like walking into the rain forest. It was filled with tropical plants and Central American artifacts. I was given a warm welcome by Peter and Christopher and sensed they had a loving relationship. My objective was to combine these elements, so I dragged plants to the fireplace, lit candles, and placed a stool in the scene.

### Posing

I had Christopher sit on Peter's lap as if he were cradling him. Then, I had them place their arms around each other and hold hands. The shape this created with their arms formed a heart. I also broke one of my own rules and placed the statue directly behind Peter and Christopher's head. I felt this helped tell the story of the spiritual side of Peter.

### The Story

The image you see was the first idea and the one I liked the best. Peter also wanted to show another side of their relationship—the not uncommon side where a father and son are at odds with each other. Surprisingly, he brought out some play guns. I photographed them back-to-back as if they were ready to duel. It was worth a try—so be sure to keep an open mind and collaborate with your subjects.

### Tips

This is the first case study to use a second light, added to illuminate the fireplace and statue. Without it, there would have been no separation of my subjects from the background.

You'll also note that I chose a slow shutter speed to capture the candles burning. I am not sure it was worth it, though; they are difficult to see against the light background. I try to use every light source in the frame, though. It is my obsession.

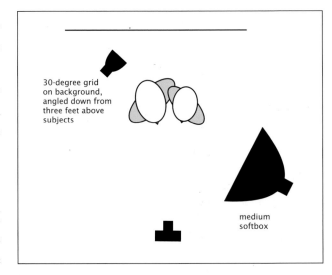

30-degree grid on background, angled down from three feet above subjects

medium softbox

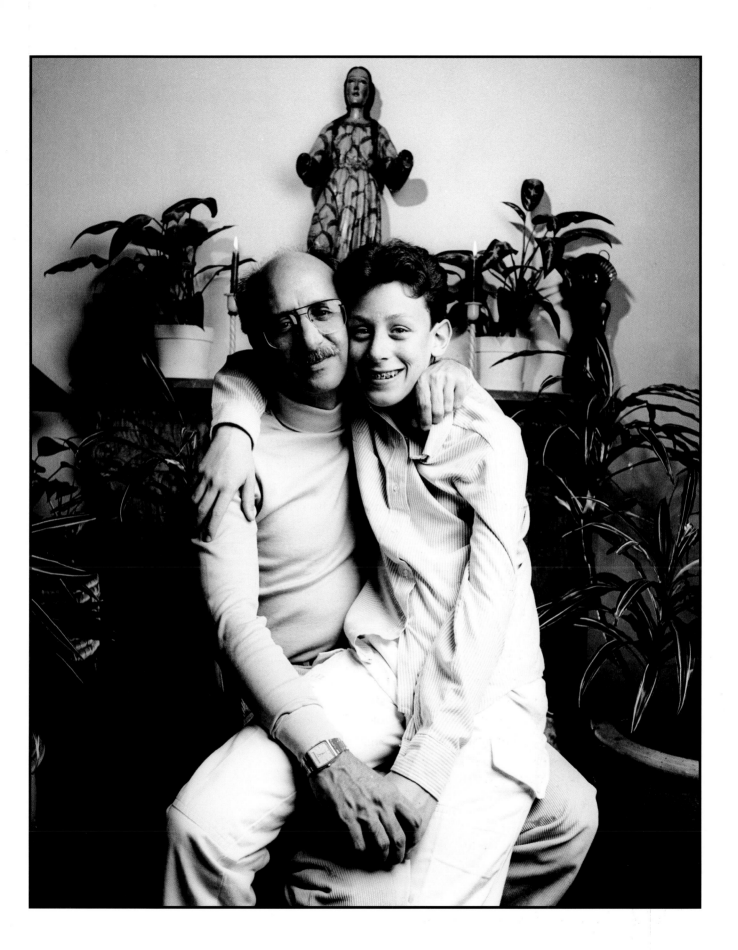

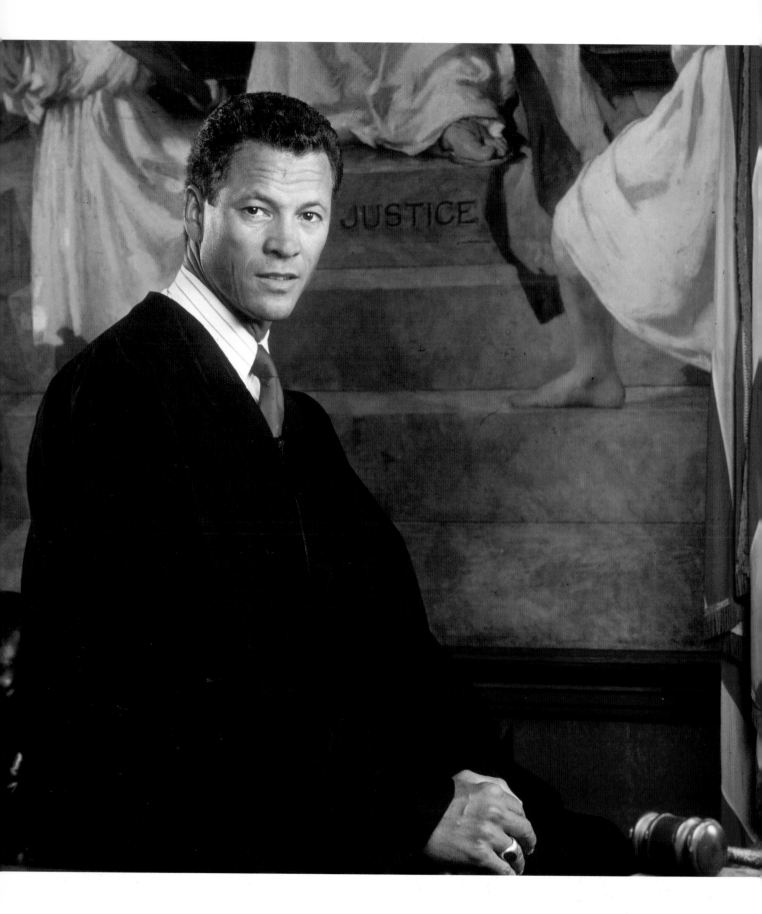

# The Real Judge

**CAMERA:** Hasselblad 503c
**LENS:** 120mm macro
**FILM:** Fuji RDP 100
**EXPOSURE:** f/8 at $^1/_{125}$ second
**LIGHTING:** two Luz 800ws power heads and three heads (medium softbox as main light; medium softbox as background light; 40-degree grid as hair light)

### Assignment

I was called by the University of Wisconsin to photograph a New York County Supreme Court judge, the Hon. Richard B Lowe III, for the cover of their alumni magazine.

### Visual Objective

I knew this was going to be for a magazine cover, so I had to keep that in mind for the layout. I was looking to create an image of a successful alumnus that showed authority and grace. The obvious location for the portrait was at the judge's bench, but rather than have him sitting in his chair, obscured behind the towering bench, I had him sit on top of the bench. The gavel, flag, and background drive home the message. I was relieved when the judge had no problem sitting on his bench (some might not have gone for it).

### Posing

The best way to depict authority is to shoot up at your subject from a low angle. Sometimes called a hero shot, this makes the subject being bigger than life. Showing grace was the other half of the equation, and having him place his right hand over his left gives the impression of being in control and at ease.

### The Story

I was sort of in awe when I entered the judge's chambers—and very curious. After introductions I started right in with the question, "What was your most challenge case?" Normally, I would start off with small talk, but for some reason I was inspired to get right to the heart of my curiosity—and most people like talking about themselves when being photographed. The judge thought for a while and started telling me about a class-action suit that was just settled by General Motors. The details gave me a new appreciation for class-action lawyers.

### Tips

When possible, I research my subject before I photograph them, something that has been made much easier by the Internet. When photographing a celebrity or CEO, befriending their assistant can also provide a wealth of information. I use whatever information I get to help guide the conversation.

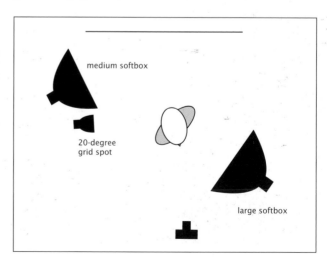

# Lights, Camera, Action

**CAMERA:** Hasselblad 503c
**LENS:** 50mm
**FILM:** Fuji RDP 100
**EXPOSURE:** f/8 at 1/15 second
**LIGHTING:** two 800ws strobe packs and one Norman 200B portable pack (medium light bank as main; 30-degree grid bouncing off ceiling; slaved portable strobe in ticket booth)

### Assignment

Theo Kalomirakis is an entrepreneur who was building high-end home theaters for the rich and famous. My assistant and I traveled to one of his sites outside New York City to do this shoot for *Manhattan Inc.* magazine (no longer in existence).

### Visual Objective

This was a fun and challenging assignment. The theater was gorgeous—it was hard to believe it was in someone's home—and Theo was easygoing. I photographed Theo throughout the theater, sitting down, standing up etc., but I needed an opening shot for the article. I wanted a fun shot that said "going to the theater." What made sense to me was to place him outside the theater with the posters and ticket booth (I also thought about placing him in the booth, but decided it wouldn't work). The challenge was shooting in mixed light and with glass in the background.

### Posing Technique

Since this was the opening shot for the article, I was thinking that the art director could place this image on the left-facing page and have space to the right of Theo for copy. I also decided it would be fun to have Theo holding popcorn and movies to keep his hands busy. I had him sideways and turned in toward the camera to close the imaginary triangle created by the marquee and his left elbow.

### Tips

The glass in the background of this shot presented a challenge. Fortunately, I always travel with black cloth, BlackWrap, and large black cards (cut and folded). I use them as gobos, employing clamps to mount them on light stands. This reduced the reflections.

I also travel with flashes that can be slaved (i.e., triggered remotely) to illuminate small areas—in this case, the ticket booth.

Finally, to record the neon marquee I dragged my shutter. More importantly, I turned off the fluorescent lights that illuminated the poster to avoid a green color cast.

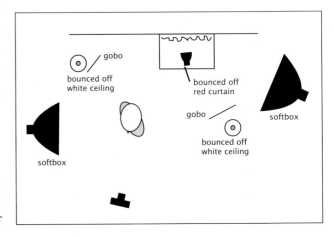

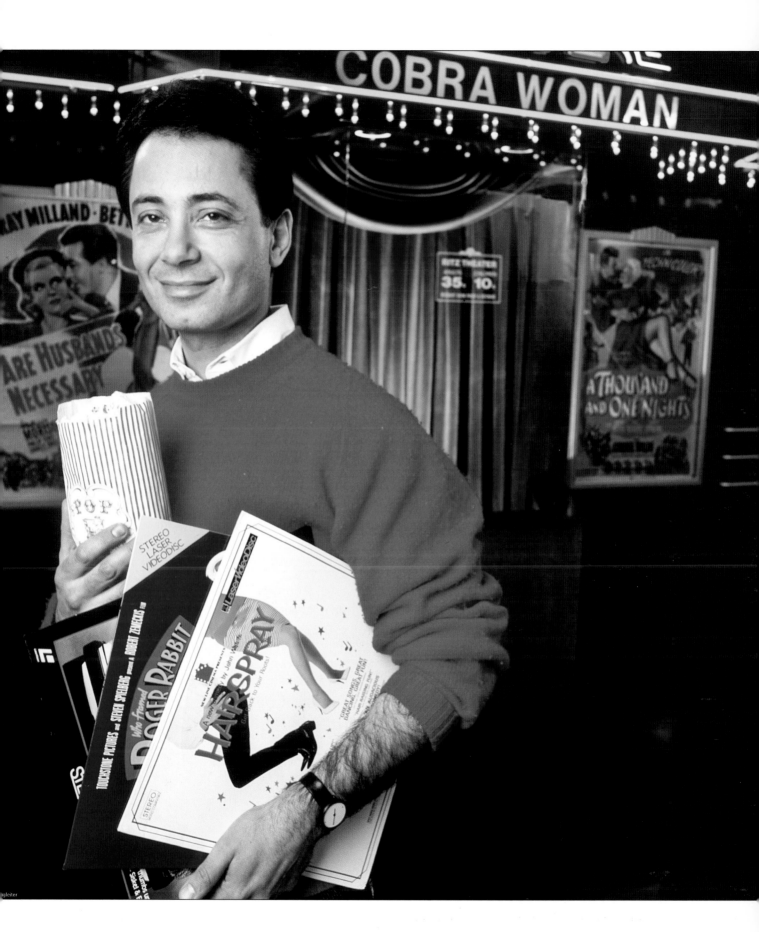

# The Fourth Round

**CAMERA:** Hasselblad 503c
**LENS:** 120mm macro
**FILM:** Fuji RDP 100
**EXPOSURE:** f/8 at $\frac{1}{125}$ second
**LIGHTING:** Luz 800ws strobe packs and a large Chimera softbox on a boom stand; large white reflector on posing table

### Assignment

One of my clients in the '90s was a celebrity stock agency called Shooting Star. Periodically, they would send rising stars to my studio to be photographed for public relations and celebrity stock. Ashley Sayers was one of the up-and-comers that I got to photograph.

### Visual Objective

Acting is a very difficult field to succeed in—and even more challenging for children, who are more vulnerable to the fleeting fame. I wanted to illustrate the toughness and the tenderness of a child actor in visually clean and concise way.

### Posing

A simple stool and posing table can be very effective for controlling your subject's movements. For this tight shot, it allowed Ashley to rest her elbows on the table and cradle her head with the red boxing gloves.

### The Story

Ashley brought wardrobe and props to the session and was enthusiastic, following directions well. Within the first hour we had enough photographs for all her public relation needs. Still, I felt I hadn't gotten "the" shot, so I went into my prop bin and pulled out a pair of man-size boxing gloves.

I wasn't sure how Ashley would react but, being the consummate professional, she cooperated. I knew

I had to try this at the end of the session when Ashley was a bit tired and her defenses were a bit down. I felt that it was at this moment I might capture a more authentic portrait of Ashley.

### Tip

When you are shooting for a client, take the photographs they want first. Then, give yourself time to take the photographs you want. They are paying your bills, but if you neglect your needs you will regret it later. Most of the images in my portfolio are the ones that landed on the editing floor of the photo editor.

When working with child actors, get them involved by asking about their favorite actors and movies. Ask them to imitate their favorite movie scenes or sing their favorite songs from Broadway. It's a lot of fun.

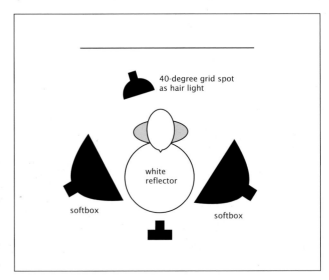

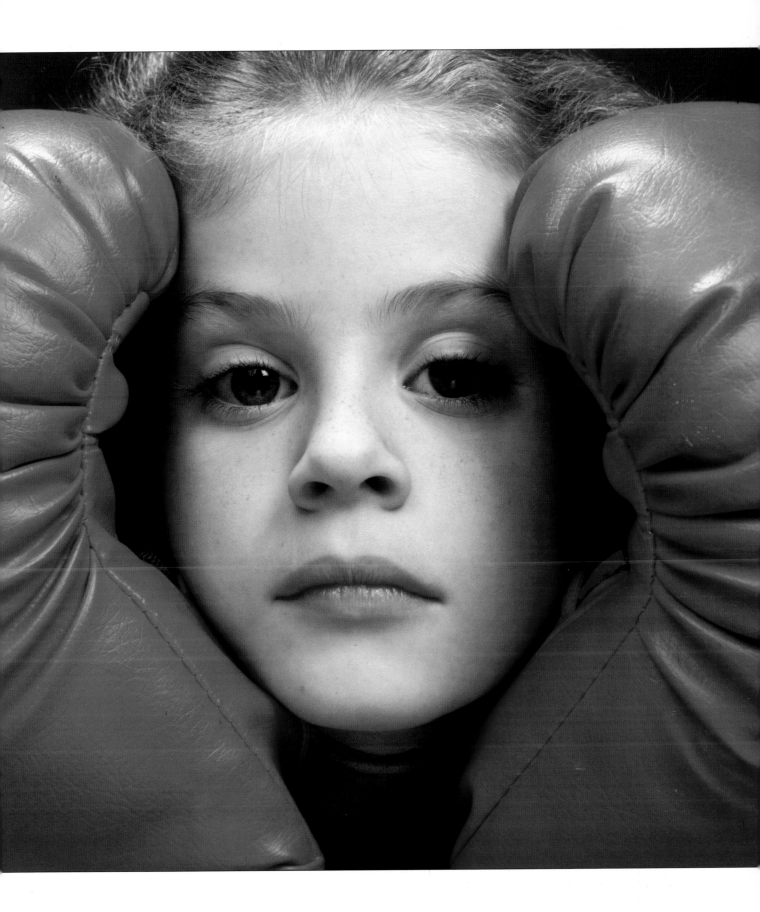

# An Acerbic Wit

**CAMERA:** Hasselblad 503c
**LENS:** 120mm macro
**FILM:** Fuji RTP 100
**EXPOSURE:** f/5.6 at ¹/₁₅ second
**LIGHTING:** Luz 800ws with spun glass over the grid; 20-degree grid with black foil affixed to the reflector to create a triangular shadow on the background

### Assignment

Channel 4 of London was doing a documentary with the author, journalist, and literary critic Christopher Hitchens. They needed a promotional image of Christopher to promote the program.

### Visual Objective

Hitchens is a controversial writer. I wanted to illustrate this by creating a somewhat mysterious environment and using a slight tilt of the camera.

### The Story

The image was photographed in a typically small, nondescript New York City apartment—not the type you see on television. When I arrived, Hitchens was working on a deadline and didn't have much time. After looking around the apartment for a location, I decided the best location was right where he was sitting. I told him to continue working at his laptop and when we were ready I would let him know.

After we set up, I asked Christopher to give me five minutes, which he did. I snapped away, and after about three rolls I was finished. He said thanks and went back to work on his laptop.

### Posing

There was not much prompting on my end. When I asked him to turn and face the camera, he clasped his hands and looked up at me. That was it.

### Tips

This was a situation where I had to alter the environment to create a more intriguing portrait. As I mentioned, the apartment was pretty plain, and Hitchens was under a deadline. To spice it up, I decided to shoot tungsten film—even though there was daylight streaming in from the windows. The trick is to convert your daylight strobe on the subject to a tungsten color balance with a CTO (color temperature orange) gel. This keeps the light color balanced on the subject while allowing the daylight to go blue.

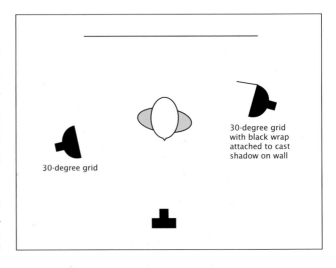

30-degree grid

30-degree grid with black wrap attached to cast shadow on wall

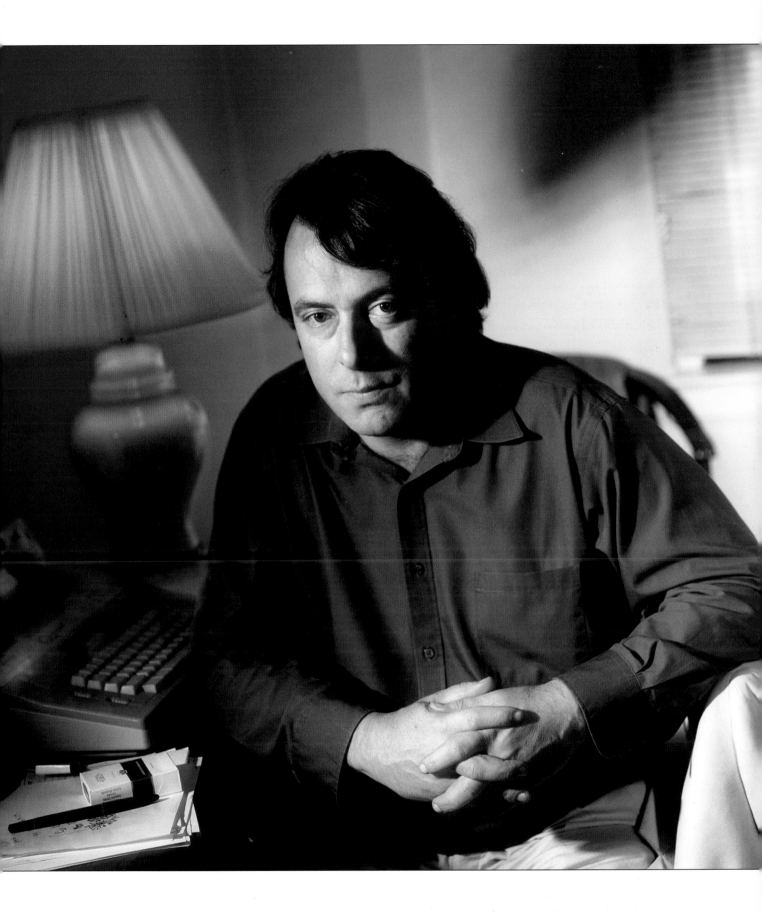

# AstroTurf® and a Rising Star

**CAMERA:** Hasselblad 503c
**LENS:** 120mm macro
**FILM:** Kodak E100 SW
**EXPOSURE:** f/8 at ¹/₁₂₅ second
**LIGHTING:** Comet 1200ws power pack with Profoto octagon softbox on a Bogen boom stand
**OTHER:** Ladder for high camera angle

### Assignment

I had gotten a call from my agent in Los Angeles to photograph the up-and-coming child actress Hallee Hirsch for publicity photos. My objective was to create a contemporary Hollywood portrait.

### The Story

When Hallee came to my studio with her father she had just finished playing in a movie, *One True Thing*, with Meryl Streep. She had been performing since she was two and was a natural to photograph.

Going through the wardrobe she brought, I noticed this odd AstroTurf-like sweater. As it happened, I had just shot a brochure for a golf company the week before and had a 4 x 6-foot piece of AstroTurf in storage. I was also thinking of Shakespeare's Ophelia (perhaps because of Hallee's flowing hair). I explained to Hallee my idea to have her play Ophelia with a twist and she was into it. I had my assistant run out and get daisies while Hallee changed into the green sweater. I set up the ladder and we began shooting.

### Posing

Since this was a low budget shoot—no prop or hair stylist—I had my assistant fan out her hair. I wanted the hair to look as if it were floating on water. I also wanted the image to look playful so I had Hallee hold one of the daisies while her other hand played with her hair. The smirk was by accident but I felt was the right expression for my concept. The publicist used the one of her grinning. (*Note:* The image was on my old web site for years and seemed to get more hits than any other image . . . hmm.)

### Tips

Props are fun and can be an inspiration. Props can also drive a concept, as noted in this example. The key to props is getting them organized. I suggest placing them in file boxes and clearly labeling the contents. When the inspiration hit during a shoot, you can then go back to your storage area and pick the right prop. If you don't have the space or inclination to shop for props, you can also rent from prop houses or do what prop stylists do—go to the store, purchase the item on a credit card, then return it after the shoot.

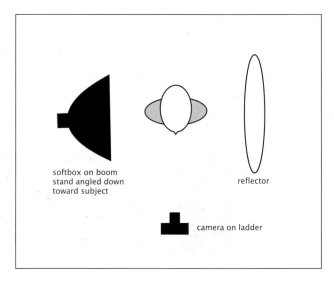

softbox on boom
stand angled down
toward subject

reflector

camera on ladder

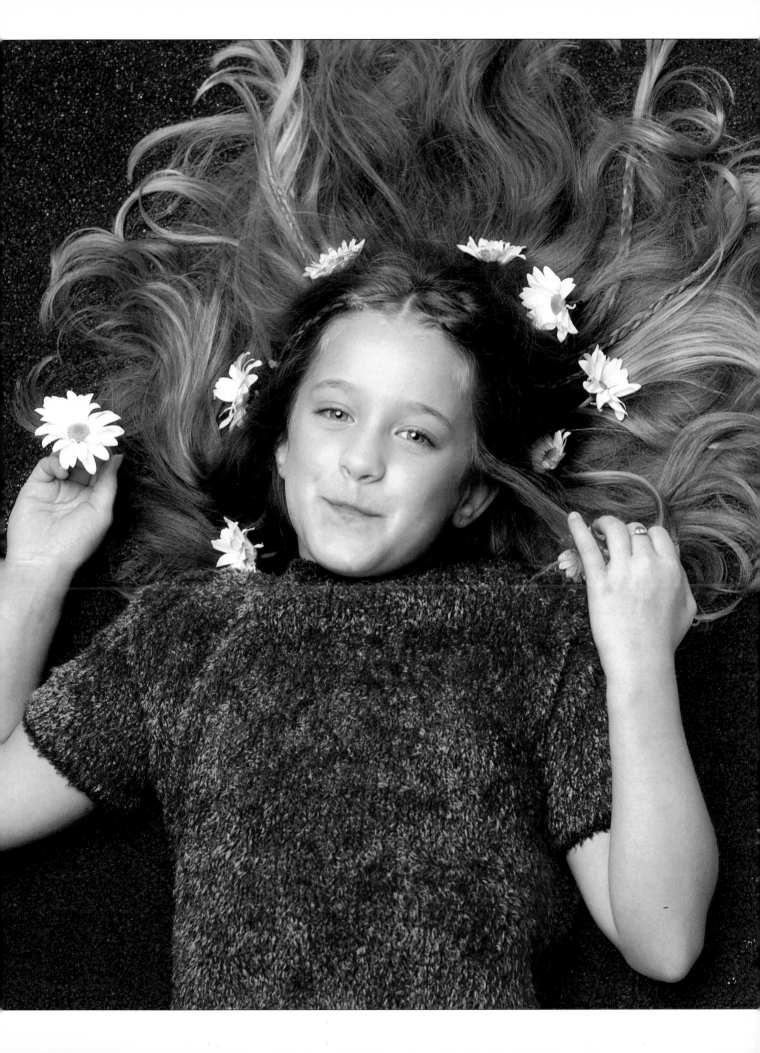

# Five-Minute Pit Stop

**CAMERA:** Hasselblad 503c
**LENS:** 50mm
**FILM:** Fuji RDP 100
**EXPOSURE:** f/8 at $\frac{1}{60}$ second
**LIGHTING:** Norman 200B through a white umbrella

### Assignment

Sports figures were also a key group I gathered for my "fathers and sons" project. I can't remember who gave me Mario Andretti's number, but I was sure grateful.

### The Story

Mario's schedule was so busy that the only opportunity for a session was with his son Michael—and it would have to be right before Michael's trial run for the Indy 500. I said "no problem"—totally disregarding the logistics of getting there.

When I met Mario, he was friendly and told me to find a place to set up; Michael would be there in twenty minutes. I quickly saw the racecar hoods sitting on end (6 and 6x) and thought they would make a great frame for the father and son. I set up my light, set my camera on a tripod, and took light readings.

When Michael arrived, we had five minutes for the shoot before his time trial. I went through about four rolls of 120 film and it was over. I thanked them for the time and wished them all the best. Mario gave his son a kiss on the lips and turned to me and said, "I always do that since I know I may never see him again."

### Posing

I wanted to build on the symmetry of the racecar hoods and have Michael and Mario mirror each other. Having them place their hands on their hips showed confidence and portrayed them as heroes. The fluo-rescent lights in the background were a happy accident; they suggest the idea of movement.

### Tips

When time is limited, you must have everything in place so you can concentrate on shooting. Of course, this is easier when you are working for yourself and don't have to satisfy a client. In instances like this, I use the tripod to restrict me from shooting too many angles. This lets me concentrate on getting the right pose and looking for the right moment.

This is a good example of underplaying the fill flash. I metered the flash at f/5.6, a stop under the ambient highlight exposure, to lighten up the shadows. This reduced the contrast but didn't give the "flash" look. It gave the image a grittier feel, which is what I wanted for these road warriors.

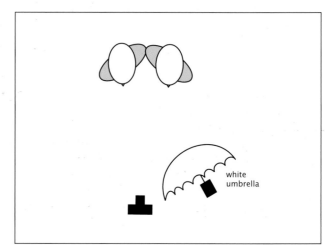

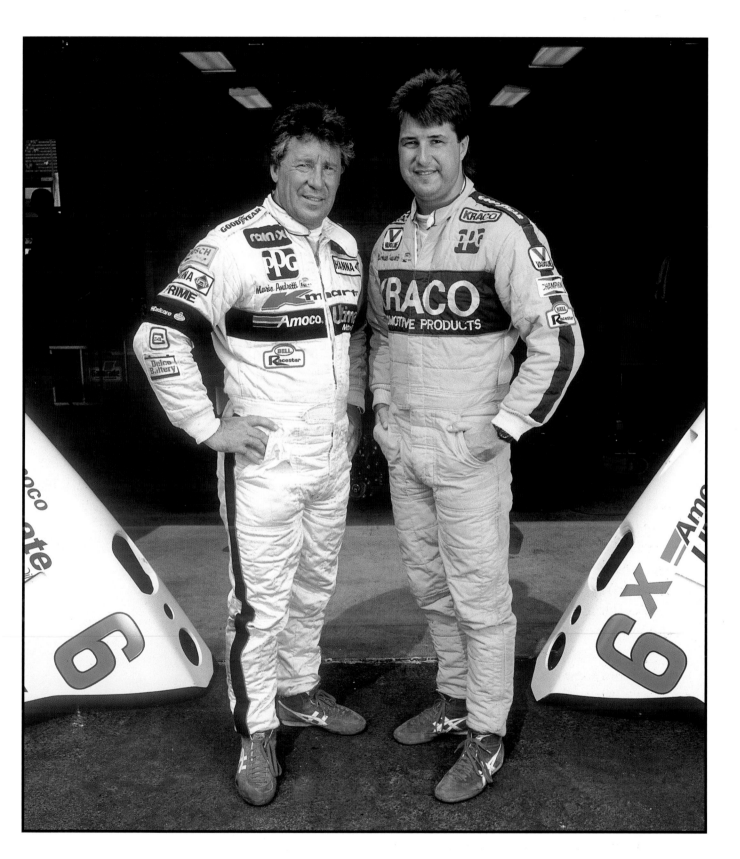

CASE STUDY #18

# Chairman of the Board

**CAMERA:** Hasselblad 503c
**LENS:** 120mm macro
**FILM:** Fuji RDP 100
**EXPOSURE:** f/8 at 1/15 second
**LIGHTING:** 1200ws pack with two heads (medium softbox for main light; 30-degree grid with 1/2 CTO filter for hair light)

### Assignment

This was an editorial assignment for the business magazine *Success*. The subject was Aaron Gold, CEO of Oxford company.

### Visual Objective

In this image, I wanted to convey a sense of determination and defiance, building on the concept of gold (from the subject's name).

### The Story

This was my first assignment from *Success* magazine and I was excited. I had been working with *Forbes* and *Business Week* and was looking forward to broadening my business-magazine client base. I had gotten a draft of the story about Gold and was very impressed. He was voted out of his company when he did not like the board's decision to change course. Before long, the company's mismanagement drove it to near bankruptcy. Then, Gold came back, worked twenty hours a day for six months, suffered a heart attack, came back after a week, continued to work. When I took his portrait, the company had grown to have two hundred employees and $400 million in assets. Wow!

### Tips

When I had got to Gold's office, I noticed the light patterns coming through the curtains. To pull in these patterns, I dragged my shutter. In order to create the illusion of a backlight, I also used a hard sidelight (with a warming gel and a grid spot), set one stop brighter than the key light.

As an aside, I was once photographing a CEO who told me he only had five minutes to spare. I took one photograph and said, "Thanks, that is all I need." The CEO seemed surprised and said, "That's all you need? What if the photograph doesn't come out?" I explained to him that I needed more than five minutes to take a good portrait and if he wasn't willing to give me more time, I would take my chances. We both laughed and he decided to give me a half hour.

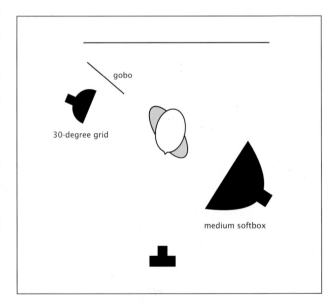

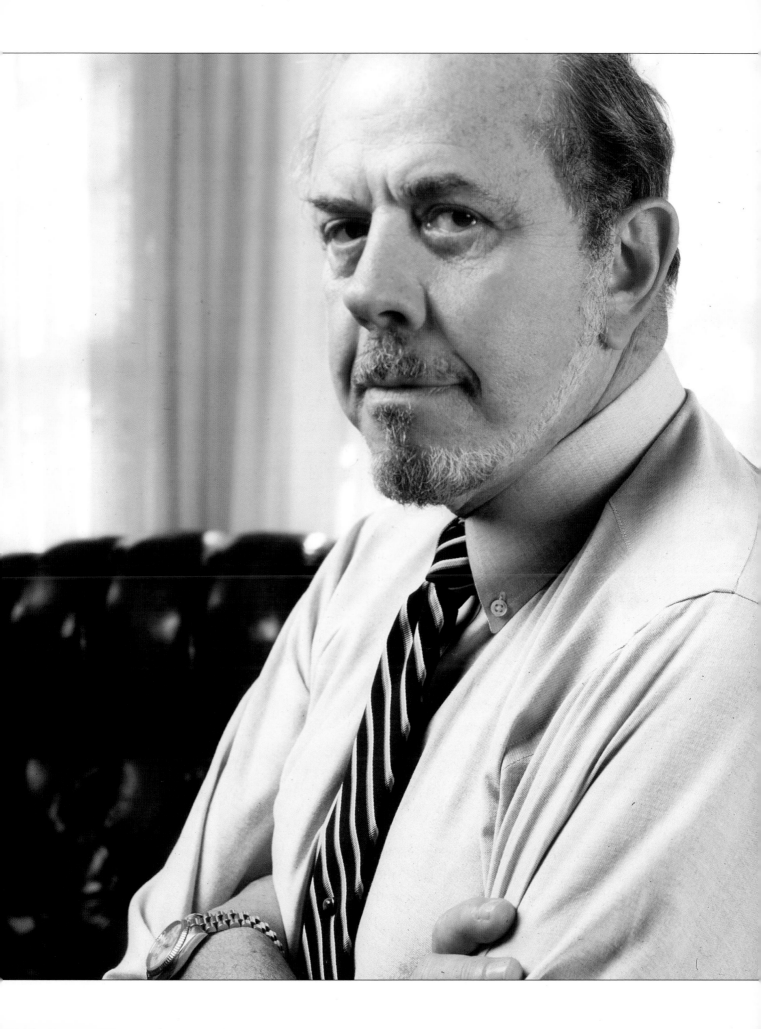

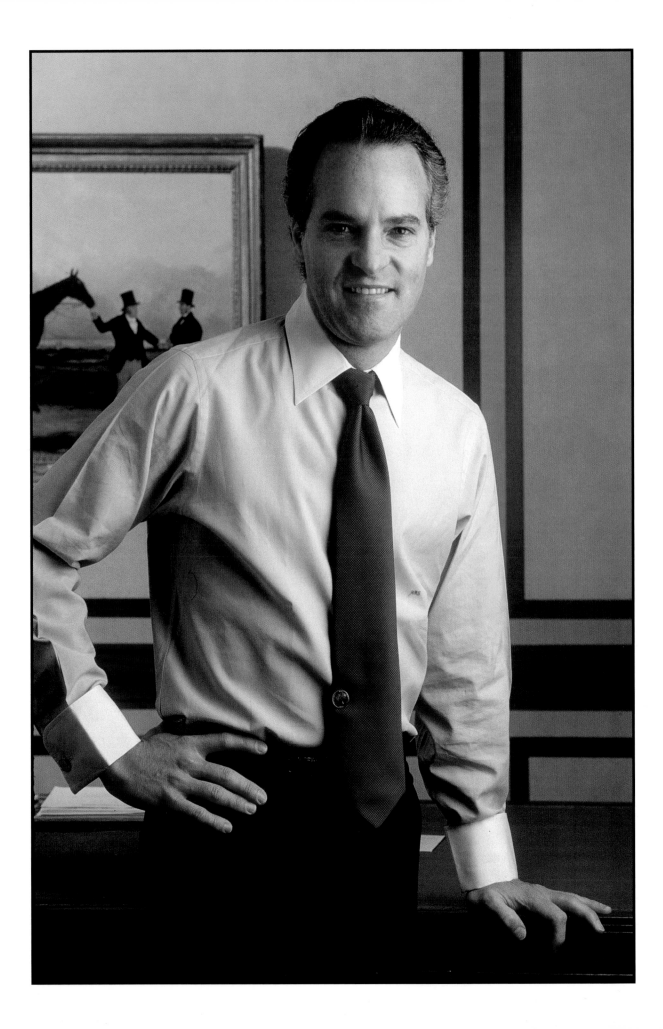

# Business Titan

CAMERA: Canon F1
LENS: 85mm f/2.8
FILM: Fuji RDP transparency film
EXPOSURE: f/8 at ¹/₁₂₅ second
LIGHTING: Luz 800ws pack with two strobe heads
(medium softbox for the main light; umbrella for the backlight)

## Assignment

*BusinessWeek* called me to photograph Henry Kravis, a managing partner of Kohlberg, Kravis, Roberts & Co., which was a major leverage buyout firm in the 1980s.

## Visual Objective

My goal was to show confidence and wealth. I also wanted to find a strong pattern for the background.

## Posing

When I photograph CEOs, there is always a great desk in the room. This was no exception, and the desk became the anchor for Kravis to lean on. To create a look of confidence I had him place his hand on his hip.

## The Story

When my assistant and I arrived at the location his secretary led us to his office and told us that Kravis would arrive in half an hour. I wasn't sure how much time Kravis was going to give me; since I might only have time for one setup and I wanted to imply wealth.

His office was filled with antiques and oil paintings. I saw the painting of the two genteel Englishmen and their horses and decided that would help narrate the photo. We moved the 200-pound desk so that I could place Kravis between the painting and the strong vertical inlay on the wall. After my second Polaroid, he walked in. I had been hoping for more time, but we shook hands and he asked what I wanted him to do. I had him take off his jacket and lean on the desk, then did some *GQ*-style shots with his jacket over his shoulder (which looked silly). The session lasted about ten minutes, then we shook hands and he left.

## Tips

Time is money in business—and the wealthier your subject is, the less time they seem to have to be photographed. The key to a successful corporate shoot is being decisive. Know what you want and don't be afraid to tell the subject.

On these shoots, be careful of what you talk about. Don't pretend you know a lot about the stock market, leverage buyouts, or municipal bonds. If you touch upon a personal connection (family, hobbies, etc.) the subject will usually stay a little longer.

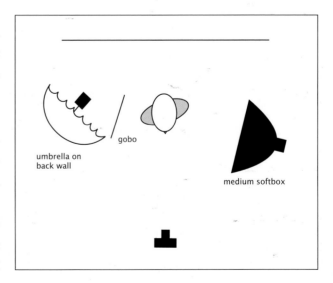

umbrella on
back wall

gobo

medium softbox

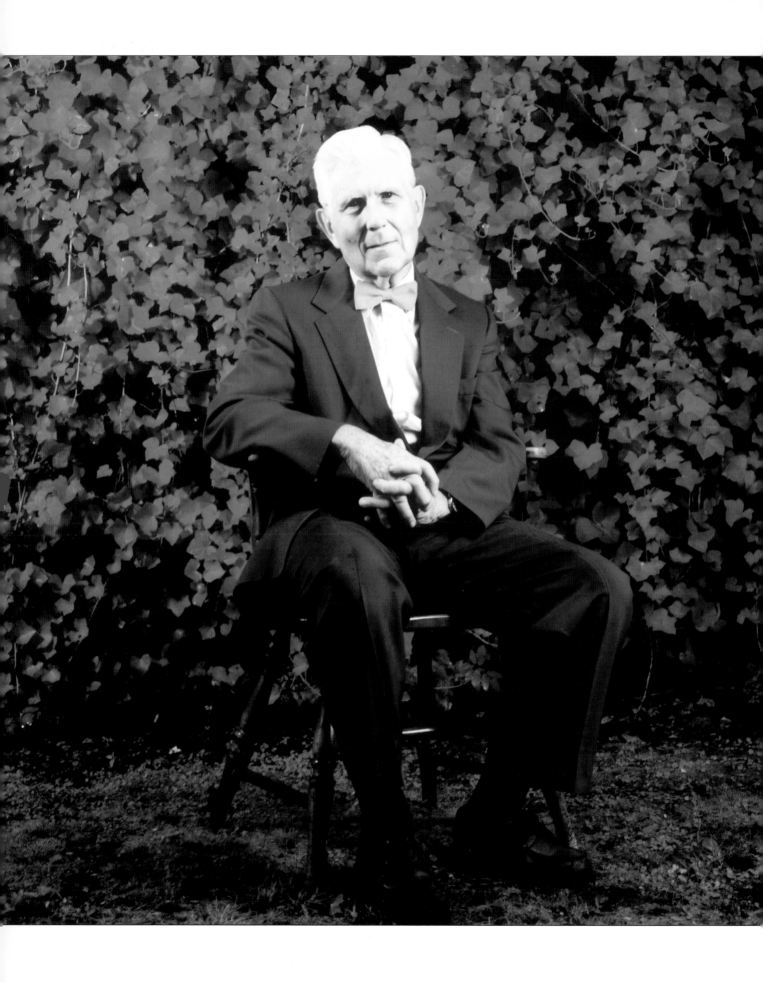

# Cognitive Bow Tie

**CAMERA:** Hasselblad 503c

**LENS:** 120mm macro

**FILM:** 120 color infrared film rated at ISO 200

**EXPOSURE:** f/8 at ¹/₁₂₅ second

**LIGHTING:** 1200ws Profoto pack and one head with a medium softbox

**OTHER:** yellow (Kodak #12) filter

### Assignment

*Brown Alumni Magazine* (Brown University) was doing a special issue on the top one-hundred graduates. They assigned me to photograph Aaron T. Beck, the father of cognitive therapy.

### Visual Objective

When I arrived at Dr. Beck's home, I noticed this great, tall, green hedge next to his home. I thought that using it as a backdrop for him sitting in a chair would create a surreal effect.

### Posing

To emphasize the unnatural setting, I used a traditional corporate pose, having my subject place his elbow on the arm of a chair and interweave his fingers.

### The Story

This was a fun assignment for me since I was teaching at the University of Pennsylvania at the time and Dr. Beck was an eminent scholar there. Alumni publications don't pay very well, so I recruited my wife Kate (a Penn alumna) to assist me. I didn't know much about cognitive therapy and realized it would be foolish of me to pretend I did since I was photographing the father of the discipline. In my research on Dr. Beck, though, I did notice he always liked to wear a bow tie. So that's how I started the conversation. He laughed when I asked him about it and started to tell about his personal life—when he first started wearing one, when he met his wife, etc. I believe the bow tie broke the ice; I wasn't sure how he'd react to the idea of sitting on an old wooden chair in front of a hedge, but he said it was "interesting." You never know what line of conversation will loosen up your subject. Taking notice of the small details about your subject shows that you are paying attention.

### Tips

Although the magazine used the image I shot with normal film I have always felt the color infrared image was much stronger. If you are interested in learning how to use it, check out my book *The Art of Color Infrared Photography,* also from Amherst Media.

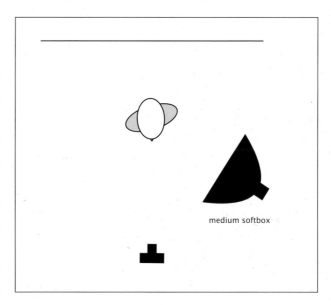

medium softbox

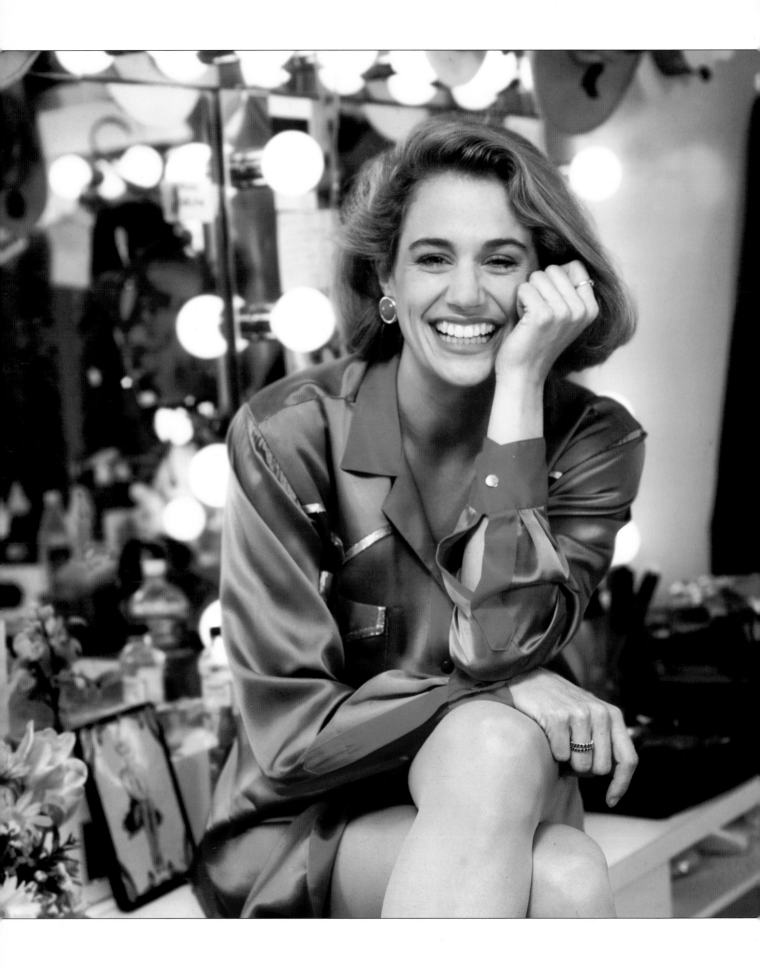

# Folly with Caddie

**CAMERA:** Hasselblad 503c
**LENS:** 120mm macro
**FILM:** 120 Fuji RVP
**EXPOSURE:** f/8 at $^1/_{15}$ second
**LIGHTING:** Luz 800ws pack; one head with a beauty dish

### Assignment

This portrait was taken for *New York Magazine*. The subject is Caddie Huffman, costar of the hit Broadway musical *The Will Rogers Follies*.

### Visual Objective

My goal was to capture the bright lights and excitement of being backstage at a Broadway musical.

### Posing

Caddie was a natural to photograph. I tried many poses with her, but having her sit on her dressing table was the best. With all the clutter and bright lights in the background, her scrunched-up position tightened the frame and drew the viewer to her great smile.

### The Story

When the photo editor at *New York Magazine* called, I learned they needed a shot taken the same evening, before the show, and film the next morning. I arrived an hour before Ms. Huffman went on stage and had to setup and shoot within a half-hour. Knowing this beforehand, I decided to keep it simple and use one light with the beauty dish. This turned out to be the right thing to do. Her dressing room was about 8 x 8-feet and filled with costumes and props; there wasn't much room for more than two people, let alone lights and an assistant. I shot four rolls before I felt I got the shot—and before I ran out of time.

After packing up, I dropped the film off at the lab and rushed a clip test. I judged the clip that evening and rush-processed the four rolls for morning delivery. The following morning I edited the film and sent my selects to the photo editor—very different than the digital workflow of today, but just as time consuming.

### Tips

When photographing a celebrity, getting friendly with their publicist can increase your access and provide some real insight to the person you are photographing. (In this case, I even got two complimentary tickets to the show.) Also, when you know you will be limited by time, it's best to work out all the details before you get to the location.

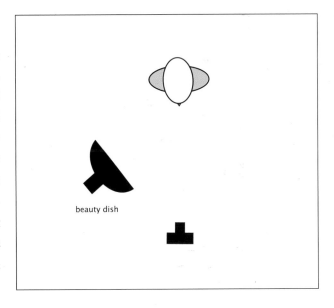

beauty dish

CASE STUDY #22

# Drummer's Dream

**CAMERA:** Hasselblad 503c

**LENS:** 120mm macro

**FILM:** 120 Kodak EPR

**EXPOSURE:** f/11 at ¹/₁₂₅ second

**LIGHTING:** Luz 1600ws pack with medium softbox as main light; medium softbox on drums behind the subject; 30-degree grid backlighting subject's head; 30-degree grid with red gel on columns; 30-degree grid on drums

### Assignment

This portrait of jazz drummer Max Roach was created for *New York Magazine*. My goal was to portray Mr. Roach with his drums in a visually dynamic way.

### Posing

Whenever you photograph a musician with his instrument, the rest falls into place. In this case, we were shooting in the sound studio where he was rehearsing. I wanted to emphasize the repetition of the similar round shapes so I shot from above looking down. I selected a telephoto lens to tighten the proximity of the shapes.

### The Story

Mr. Roach had recently returned from Japan, where he was playing and living with the Kodo drummers on Sado Island. He was inspired by his trip and brought back some traditional Japanese drums (those are the colorful ones in the background). He was already at the studio when I arrived with my assistant, so I asked him to play while we set up. When I was done, I signalled him to stop and asked him about his trip to Japan. He lit up and started to describe the experience. Then I just asked him to smile, took a couple of rolls, and gave him my thanks. He continued to play while we broke down the lights and packed. When I waved good by, he stopped playing, said it was a real pleasure, and went back to drumming. That was cool.

### Tips

I found all the visual props I could ever have wanted in the sound studio. Before I started moving anything, though, I cleared it with the manager. I also took a Polaroid so that I could put back all the drums where they were originally placed (you could, of course, do the same thing today with a digital image). I learned this when I started shooting architecture and would sometimes have to move furniture to create a stronger image. I have also learned—the hard way—to ask before I move anything in a shot. When I was photographing composer Philip Glass at his home, his composing area was a mess with scores, music paper, and books. I started straightening up to create a "clean shot" when Mr. Glass walked in and looked at me aghast. I'll never do that again.

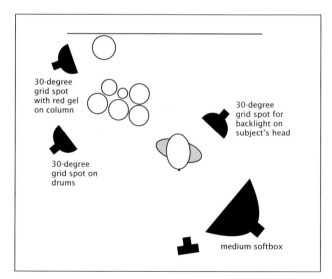

30-degree grid spot with red gel on column

30-degree grid spot on drums

30-degree grid spot for backlight on subject's head

medium softbox

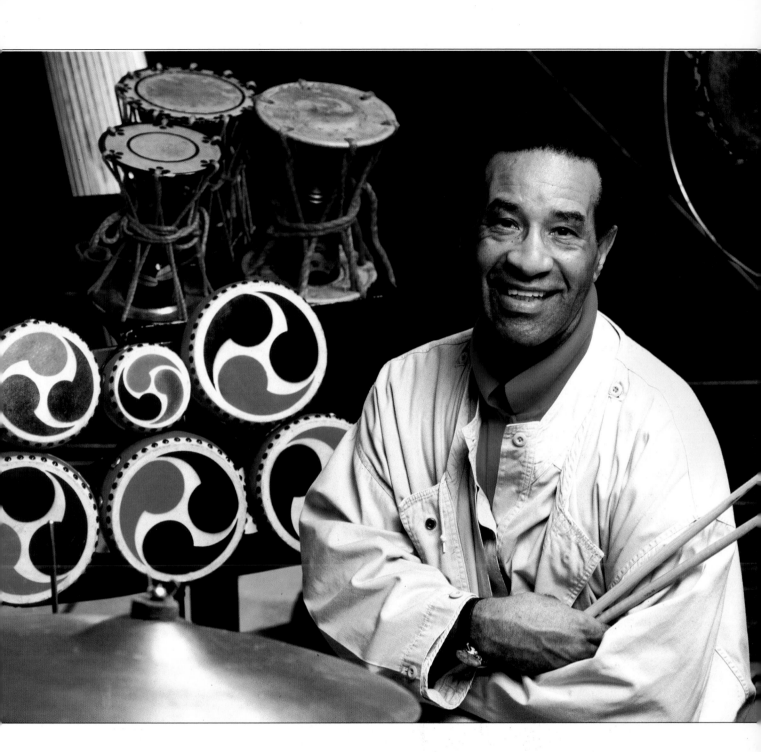

# The Gun Club

CAMERA: Hasselblad 503c
LENS: 120mm macro
FILM: 120 Fuji RDP
EXPOSURE: f/11 at ¹/₁₂₅ second
LIGHTING: three Luz 800ws power packs with four strobe heads; two softboxes

### Assignment

I was looking for distinctive families when the publisher of my *Fathers and Sons* book referred me to the Wilson clan. Larry Wilson (a.k.a., R.L. Wilson), who is shown standing on the left, had published a book with them titled *Colt: An American Legend.*

### Visual Objective

Since Mr. Wilson is one of the most published authors in arms collecting, it only made sense to photograph him, with his father and sons, bearing arms.

### The Story

When I arrived at Mr. Wilson's home in Connecticut I saw the amazing collection of arms, racecars (he had a Formula-1 car in his living room), and hunting trophies scattered throughout the home. There was so much to take in that it was difficult to frame a portrait at first. It was only when I met his father, a noted bookbinder, that I finally got centered and realized what my frame would be.

I realized that he needed to be the center of group, so my assistant and I moved the furniture—elephant-foot ottomans, Formula-1 racecars, the usual stuff—and set up the lights . . . *many* lights. (*Note:* The balcony was a real asset in setting up the background lights.) Once we were all set up, we brought the family in, set them in their places, and began the photo session.

### Posing

This was a very challenging setup. I was dealing with strong vertical lines (the white columns) and all kinds of background distractions. The first thing I did was anchored the grandfather in a chair, then surround him with his son and grandsons. I (very!) carefully positioned the rifles to avoid any of them seeming to protrude from the heads or bodies. Finally, I shot from above the family looking down to create separation from the back column and Larry's head.

### Tips

Environmental portraiture is always challenging, so take some time to process the surroundings and visualize how it relates to your subject.

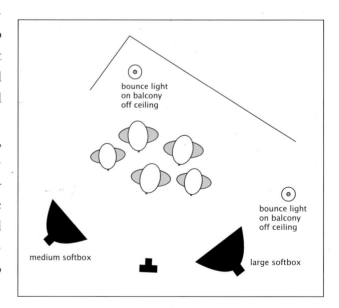

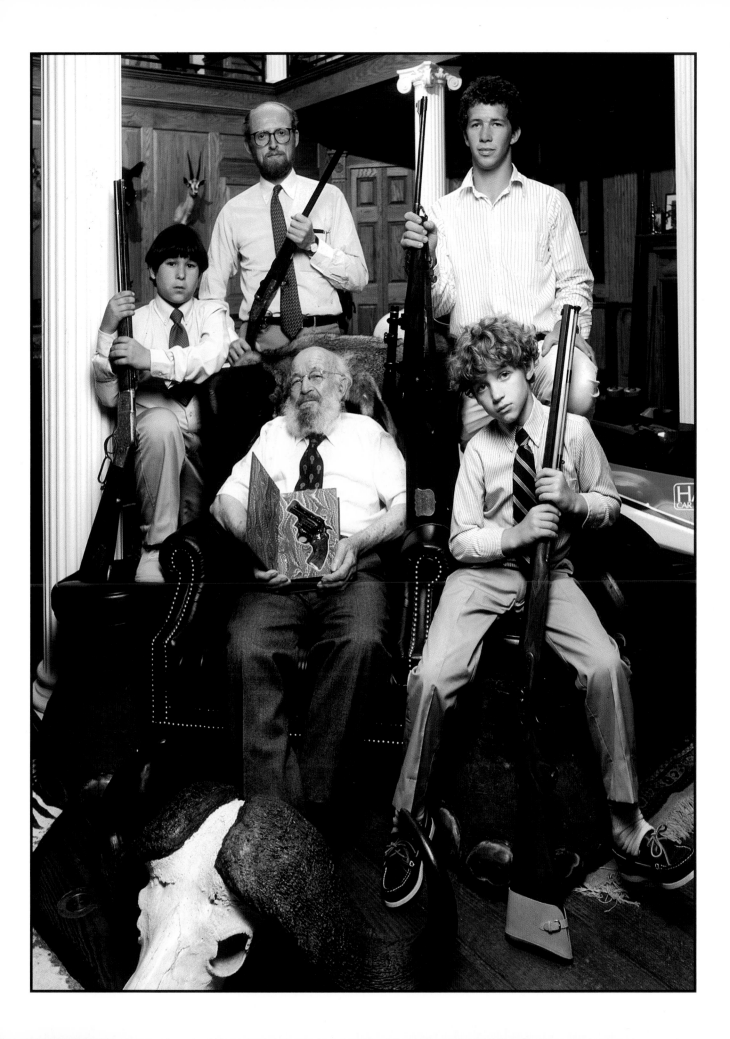

CASE STUDY #24

# The Beach Umbrella

**CAMERA:** Hasselblad 503c
**LENS:** 50mm
**FILM:** 120 Fuji RDP
**EXPOSURE:** f/8 at ¹/₁₂₅ second
**LIGHTING:** Norman 200B with white umbrella

### Assignment

Another image I created in the course of my "Fathers and Sons" project was of Tom Midgley and his son.

### Visual Objective

My objective was to create an image that would reflect a sense of openness and security.

### Posing

I wanted to portray security in this relationship, but Tom's son was a bit too big to put in his lap. I decided it would reveal more about growing up if his son was sitting on the arm of the chair.

### The Story

It is difficult to stay away from the beach when I am in Los Angeles—and yet, up to this point in my "Fathers and Sons" project, I had not photographed any of the Los Angeles fathers and sons on the beach. When I got this opportunity to photograph Tom Midgley and his son on the beach, I was excited.

My assistant Martin Semjen (a friend, not a photographer) and I dragged the gear, chair, and umbrella across the beach to the perfect spot. We had about a half hour to set up before the sun would be setting, which left me about fifteen minutes of good twilight to shoot. Tom and his son arrived as the sun was setting behind the bluff and I started shooting. About five minutes after the sun had dropped I got my shot.

### Tips

Working on sandy beaches with strobe lights can become a nightmare if you are not properly equipped. I always bring a weight—either an empty sandbag that you can fill at the beach, a gallon jug (with a hook) that you fill with ocean water, or a Bogen super clamp with a U-hook you can hang the power pack on. In addition, I bring large plastic garbage bags to place over my camera bag, strobe pack, and any other equipment I need to keep sand off. Finally, be sure to pack a can of compressed air and a digital sensor cleaner.

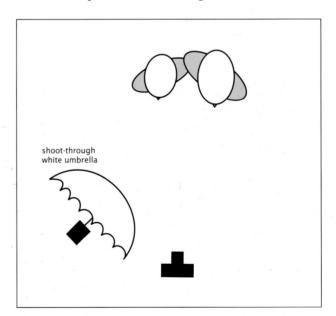

shoot-through
white umbrella

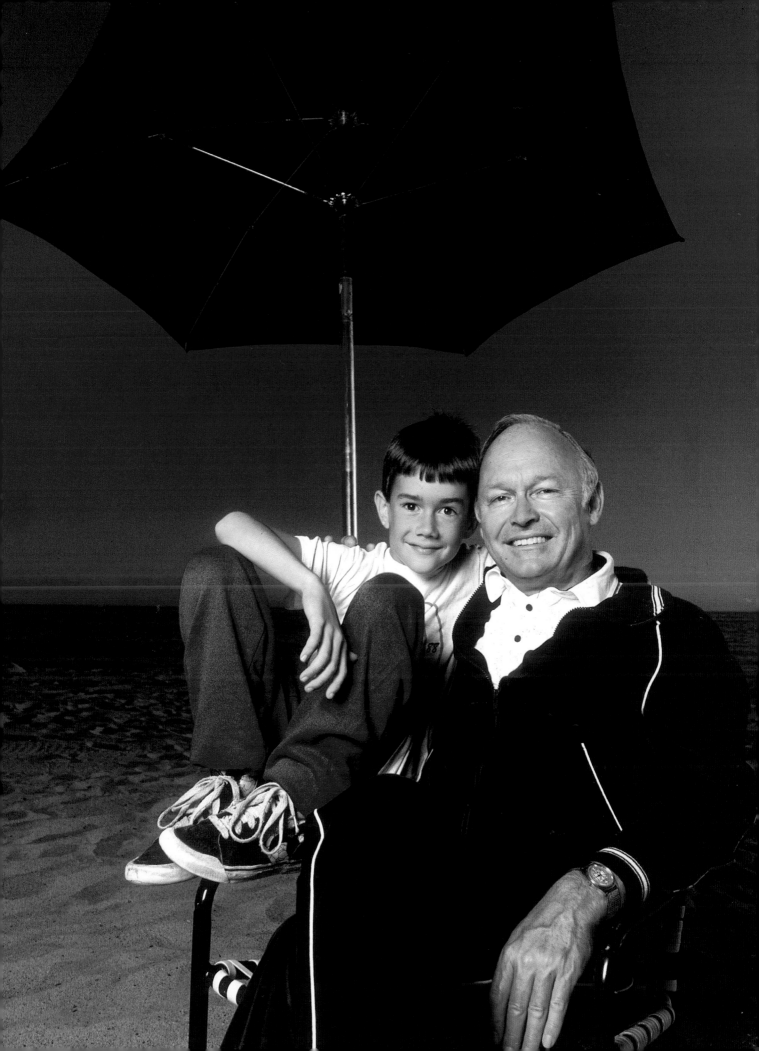

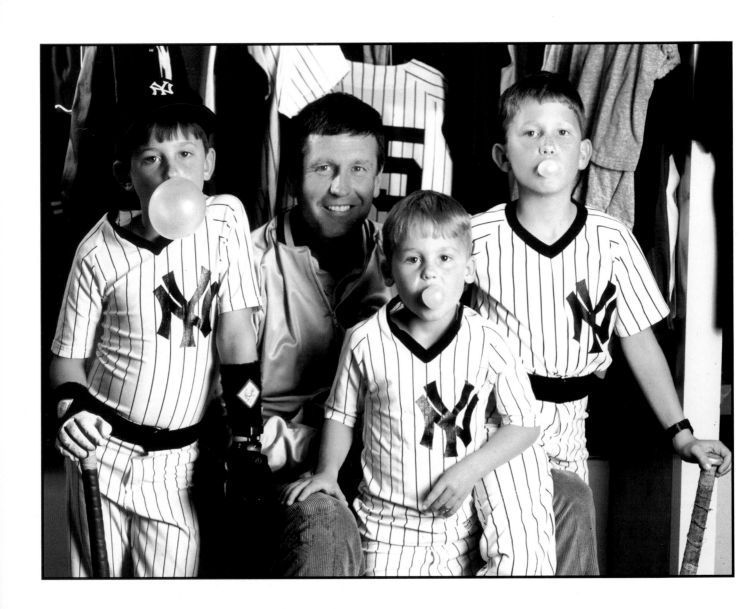

# Yankee Stadium

**CAMERA:** Hasselblad 503cw

**LENS:** 120mm macro

**FILM:** Kodak 120 EPP

**EXPOSURE:** f/8 at $^1/_{15}$ second

**LIGHTING:** Luz 800ws power pack with large Plume softbox to light family; 30-degree grid to light uniform and Mr. John's face

### Assignment

I wanted to photograph some athletes for my "Fathers and Sons" project, so I wrote to the Yankees' front office to ask if there were any baseball players I could photograph for a book I was working on. To my surprise and delight, they got back to me and suggested Tommy John. Not only was he a great pitcher, he was also a great humanitarian who adored his family.

### Visual Objective

I wanted to capture a behind-the-scenes look at the next generation of baseball players.

### Posing

To prevent Mr. John from towering over his sons, I sat him down and placed his sons around him. The baseball bats were then added for his sons to lean on.

### The Story

I arrived at Yankee stadium about an hour before the shoot and scouted around. (I have to admit, it was a thrill to walk out of the Yankees locker room onto the playing field—the same path walked by Babe Ruth, Lou Gehrig, Micky Mantle and other baseball greats.)

I realized that the shot I wanted to take was in the Yankee locker room. To my surprise, when the family arrived they were all wearing Yankees uniforms. I placed them into position and began shooting. While I was shooting I noticed all the boys were chewing gum. Rather than having them spit it out, my first instinct, I decided to have a contest. I asked them to see who could blow the biggest bubble. That was the shot.

### Tips

People always ask me how I got the opportunity to photograph so many famous people for this project. This simple truth is, I asked. As a portrait photographer, you can't be shy about asking for what you want. The worst thing that could happen is they say no and you move on. I asked more than a hundred fathers and sons to sit for me, and only six declined. That is a good percentage.

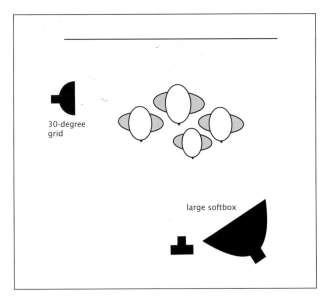

30-degree grid

large softbox

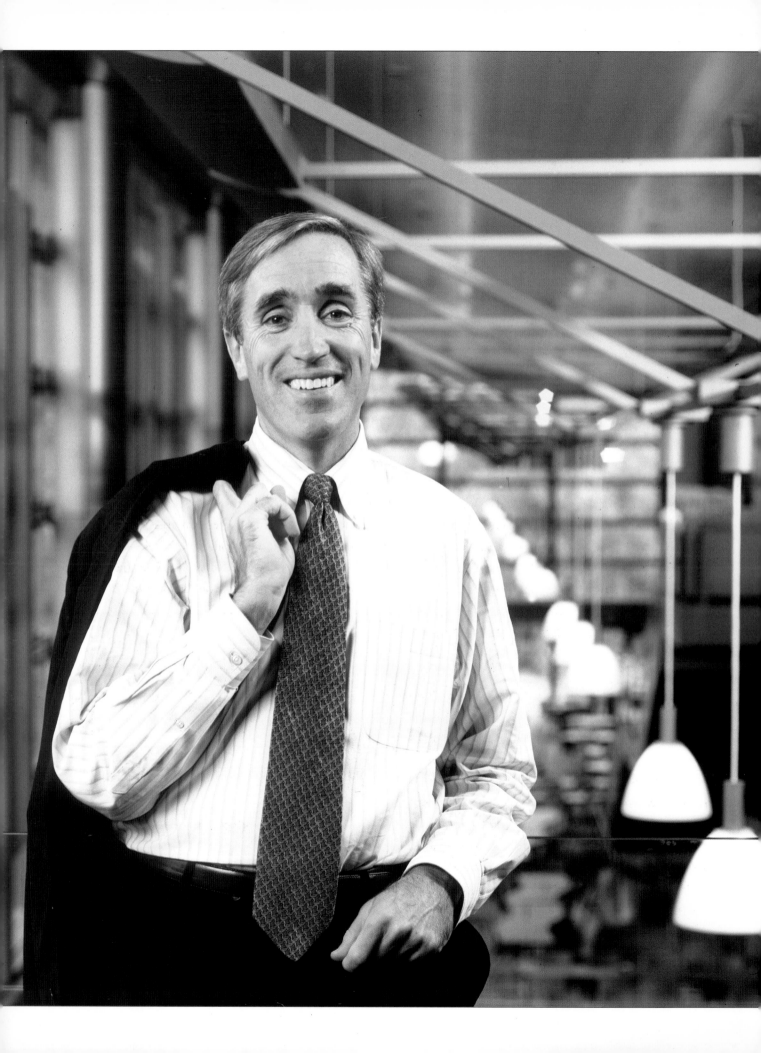

# Vanguard Chief

**CAMERA:** Hasselblad 503cw
**LENS:** 120mm macro
**FILM:** Kodak EPP
**EXPOSURE:** f/8 at $^1/_{30}$ second
**LIGHTING:** large softbox for the main light; white reflector for fill

### Assignment

*Business Week* magazine hired me to photograph CEO John Brennan of the Vanguard Group.

### Visual Objective

I wanted to place Mr. Brennan in an unbusinesslike environment with a strong graphic background.

### Posing

I call this the "GQ" pose. I don't often use it, but it seemed to fit Mr. Brennan's personality. What I had read about him was that he was a real hands-on executive who would periodically even answer calls from customers—pretty impressive for a guy whose company manages hundreds of billions of dollars. The glass ledge allowed him to lean back, relaxing his pose.

### The Story

When I arrived at the Vanguard headquarters (two hours before the session to ensure I'd have time to scout the location) a public relations person showed me around. It was raining, meaning working outside was not an option, so I decided to go to the cafeteria for some tea—a lucky break. When I entered the top level of the high-tech cafeteria, I saw my frame: an overview of the entire space with exposed beams, hanging light fixtures and long glass windows.

My assistant and I set up one light (a large softbox) on a portable boom stand. I took some Polaroids of my assistant and adjusted my shutter speed until the light looked balanced. Mr. Brennan soon arrived and asked what he should do. He smiled when I told him I was going for the "James Dean look." I took about four rolls of film in fifteen minutes, then thanked him for his time.

### Tips

Hallways, lobbies, entryways, and stairwells are often more interesting than offices, so don't overlook them in your location scouting. Reception areas also tend to be well decorated in high-end corporations—but to shoot there, you'll have to convince the client to close down the area temporarily to avoid distractions.

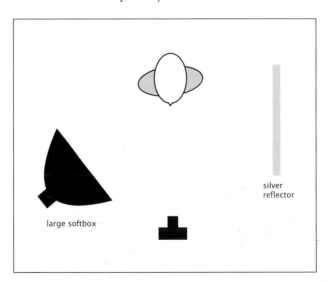

large softbox

silver reflector

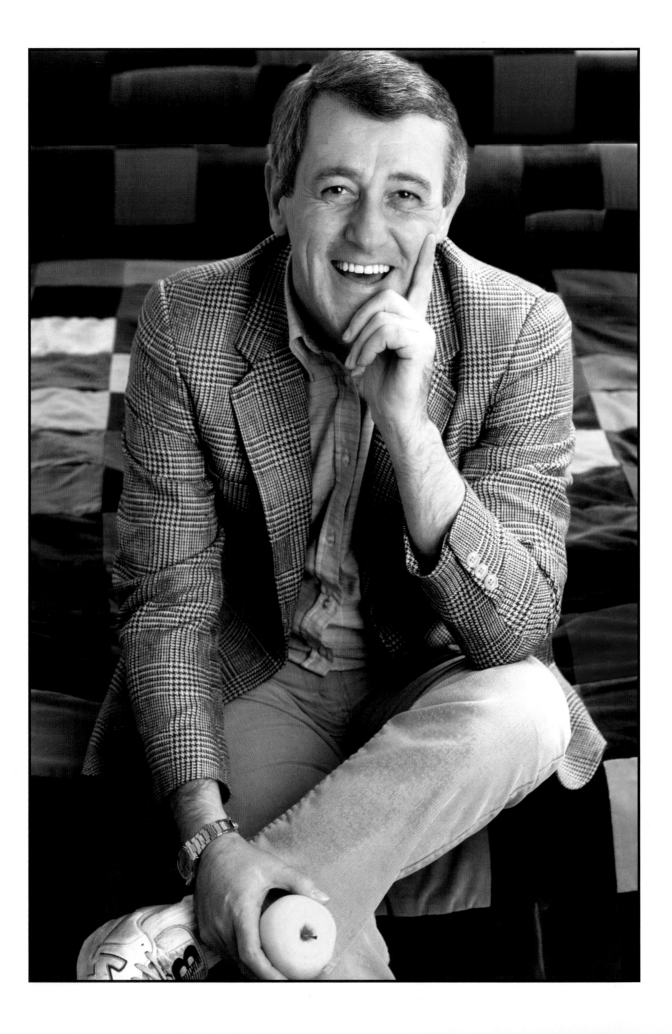

# House of John

**CAMERA:** Hasselblad 503cw
**LENS:** 120mm macro
**FILM:** Fuji RDP
**EXPOSURE:** f/5.6 at $1/125$ second
**LIGHTING:** Luz 800ws pack with medium softbox as main; Luz 800ws pack with reflector placed behind the subject and bounced off white ceiling

### Assignment

*Elle* magazine assigned me to photograph actor John Mahoney.

### Visual Objective

I wanted to portray a lighter side of John Mahoney, the everyman.

### Posing

This is what I call the circular pose. The positioning of Mr. Mahoney's arms and legs forces your eye to circle the subject. If you start with the apple, travel up to the face down the left arm you end up back at the apple (read on for more on why this prop was selected).

### The Story

This photo session took place in a nondescript Manhattan apartment where there wasn't much to work with but the colorful quilt. Mr. Mahoney was a teacher before he went into acting. That inspired me to use apples as a prop. With these two visual elements, apples and a quilt, we improvised the whole session.

I started out by having him toss the apple, shooting with the New York City skyline in the background. Later, I had him put on his bathrobe and get into bed, reading Shakespeare with an apple on his head—a William Tell scenario.

*Elle* ran the image of the apple toss, but I felt the image here really captured his playfulness. (*Note:* Mr. Mahoney won the Tony award that year for his portrayal of Artie in *The House of Blue Leaves.*)

### Tips

Sometimes life hands you lemons and you have to make lemonade. When I walked into the nondescript apartment, I sighed. Fortunately, the quilt, the apple, and—of course—a fun subject helped transform what could have been a very mundane image into an interesting one. Always be on the lookout for visual elements to complement the portrait—and never be afraid to share them with your subject. I wasn't sure how Mr. Mahoney would react when I asked him to sit in bed with an apple on his head, but he thought it was fun and creative idea. In turn, I gained his trust.

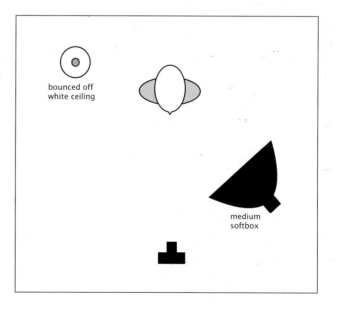

bounced off white ceiling

medium softbox

# Robert Lee Morris Meets Jackson Pollack

**CAMERA:** Hasselblad 503cw

**LENS:** 120mm macro lens

**FILM:** Fuji RDP

**EXPOSURE:** f/8 at $^{1}/_{125}$ second

**LIGHTING:** Comet 1200ws pack (beauty dish with 30-degree grid for main light; reflector with 30-degree grid for hair light; two umbrellas on background)

### Assignment

I was assigned to photograph jewelry designer Robert Lee Morris for the cover of a Fairchild Publication, Inc. magazine.

### Visual Objective

Mr. Morris was becoming very famous for his work in silver and gold and was known for using deconstructed plaster busts to display his creations. I asked him to bring samples of his work and a couple of busts to the session. I wanted to create a strong visual that reflected his creativity with gold and silver.

### Posing

It is always easier to pose your subject when they have something to hold. This pose was centered on framing the bust. I had Mr. Morris cradle the bust, turn sideways to the camera, and—on the count of three—turn his body toward the camera. After repeating this motion many times, he was feeling very comfortable.

### The Story

There are some benefits, in addition to the notoriety, to shooting covers for publication. First, there is a specific format; the image will be a vertical with space above the subject for the masthead. Second, the art director will be able to direct the point of view. Additionally, there is more pressure to create an arresting image to draw attention the magazine.

For this shot, I was agonizing over the background. Before the Internet, when this happened I would go to art galleries. In this case, I stopped in a Soho gallery featuring a show of early Jackson Pollack and got the idea to have dripping silver paint on the backdrop. I proposed the idea to the art director and she agreed—but also suggested I shoot it on a plain blue background. Happily, the publication ran the shot with Pollack-esque backdrop.

### Tips

Never be afraid to suggest ideas to your client; they hired you because of your talent and skills. They may not always agree with your ideas, but they will appreciate your creative input. Of course, you should always cover yourself by shooting what the client wants.

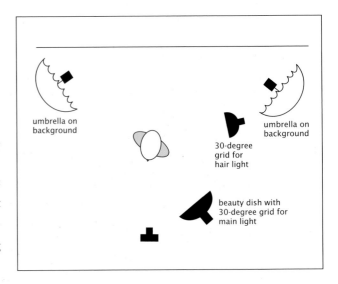

umbrella on background

umbrella on background

30-degree grid for hair light

beauty dish with 30-degree grid for main light

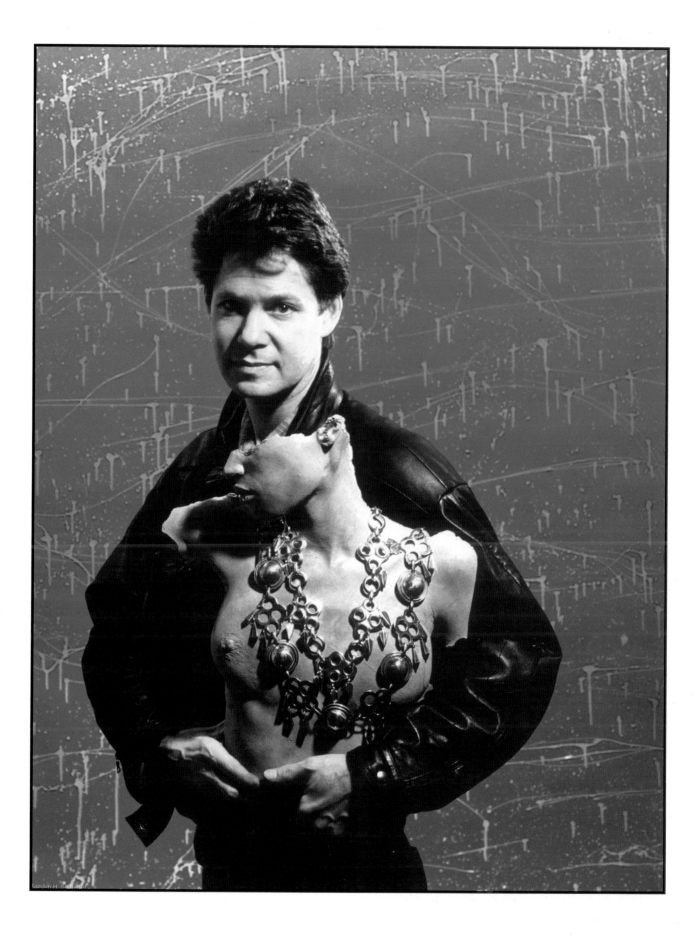

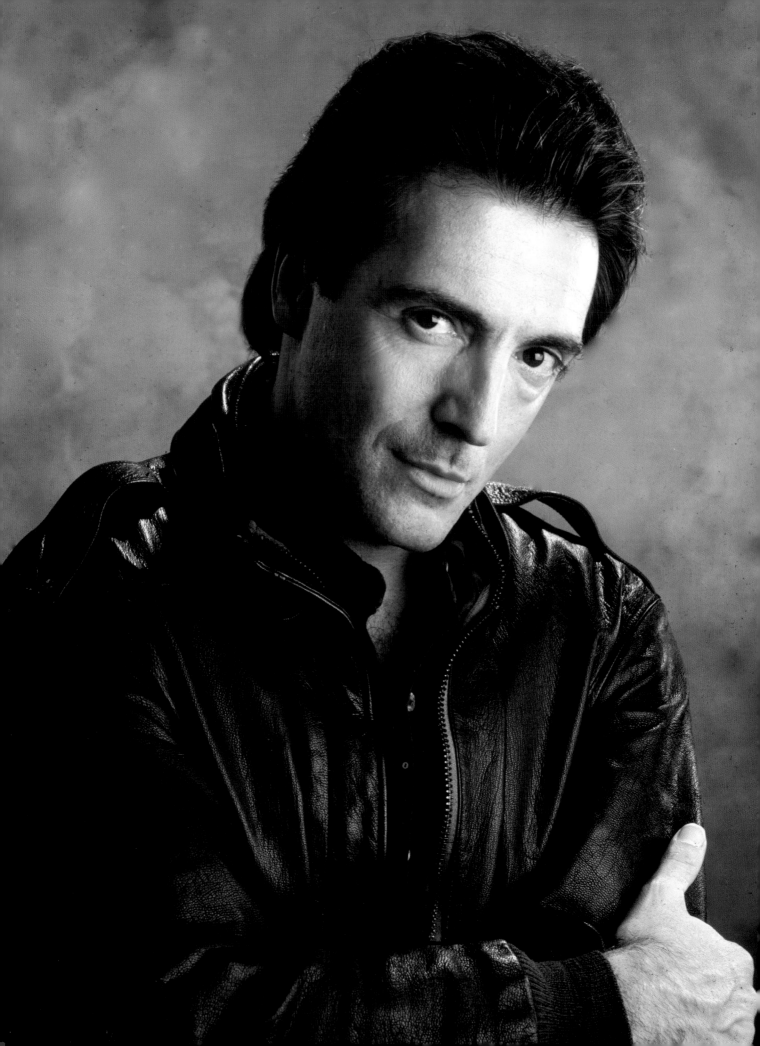

# Tender Tough Guy

**CAMERA:** Hasselblad 503c
**LENS:** 120mm macro
**FILM:** Fuji RDP
**EXPOSURE:** f/8 at $^1\!/_{125}$ second
**LIGHTING:** Profoto 800ws pack with medium softbox as main light; silver reflector for fill; diffused 40-degree grid on background

### Assignment

My celebrity stock agency assigned me to photograph the actor Armand Assante at his home. The images were for use in promoting the actor.

### Visual Objective

Mr. Assante is known for his tough-guy roles, and I wanted to reflect that in his wardrobe and the texture of the image. The black leather jacket against the mottled canvas background seemed to set the stage.

### Posing

Mr. Assante was a natural in front of the camera. This image was created during the last setup of the day and we were all tired. This was a good thing, though, because Armand was letting down his guard in terms of posing. Having him tuck his chin in, wrap his arms around himself, and look straight into the lens produced a strong look.

### The Story

This was a fun day. My assistant and I packed up the car and drove north out of New York City to Mr. Assante's upstate New York farm. He had given me the whole day to photograph him and was open to all my ideas—which doesn't happen too often. I set up a studio to shoot the publicity shots, then scouted around the farm and set up additional shots at the horse stable, inside the house in the library, in the living room,

and so on. This simple one is still one of my favorites, though. It seems to capture Mr. Assante's personality.

At the end of a long day of shooting, Mr. Assante invited my assistant and me to stay for dinner. He had prepared a great Italian meal, and we ended up eating and drinking until midnight.

### Tips

Always try to create lighting that matches your subject and the mood.

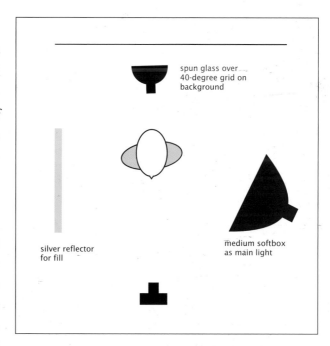

spun glass over 40-degree grid on background

silver reflector for fill

medium softbox as main light

CASE STUDY #30

# Actors and Their Art

**CAMERA:** Hasselblad 503cw
**LENS:** 50mm
**FILM:** Fuji RDP
**EXPOSURE:** f/8 at 1/30 second
**LIGHTING:** three Profoto packs with four strobe heads; one softbox

### Assignment

I was asked to photograph actress Claire Trevor, best known for her femme-fatale roles in film noir, for a book about actors and their art.

### Visual Objective

The author wanted a photo of Ms. Trevor painting in her art studio, which I shot. However, I found this cinematic heroine to be so gracious and charming that I wanted to create an additional image that portrayed her looking regal and dignified.

### Posing

I call this the "royal" pose. It is a traditional pose when the subject sits upright, crosses their legs, and places one hand over the other.

### The Story

Ms. Trevor lived in New York City's Pierre Hotel and, in her retirement, was spending a lot of time painting. When we arrived, she greeted my assistant and me warmly, wearing a painter's smock and heels.

I had read about her career and knew she was good friends with John Wayne, so I asked her a lot of questions about their friendship and she spoke very candidly. It was fun and she really liked strolling down memory lane.

I got some nice portraits of her painting during that conversation but felt I needed to capture her more like

a movie star, so I asked her if she would mind changing into something more formal and she agreed. My assistant and I then set up lights while she changed. When Ms. Trevor came out her dressing room, she looked like a star. She was wearing a classic black dress and had adorned herself with elegant jewelry.

### Tips

I have found that the best way to work with complicated lighting setups is to break them down. Start with the main light, fill, and hair lights, then move on to lighting the background. The reading from your main light will dictate the intensities of the other lights. The key light on Ms. Trevor was f/8, the bounce light above her was f/11, the background light was f/8.

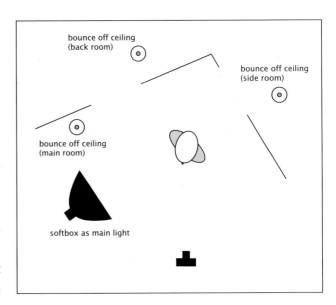

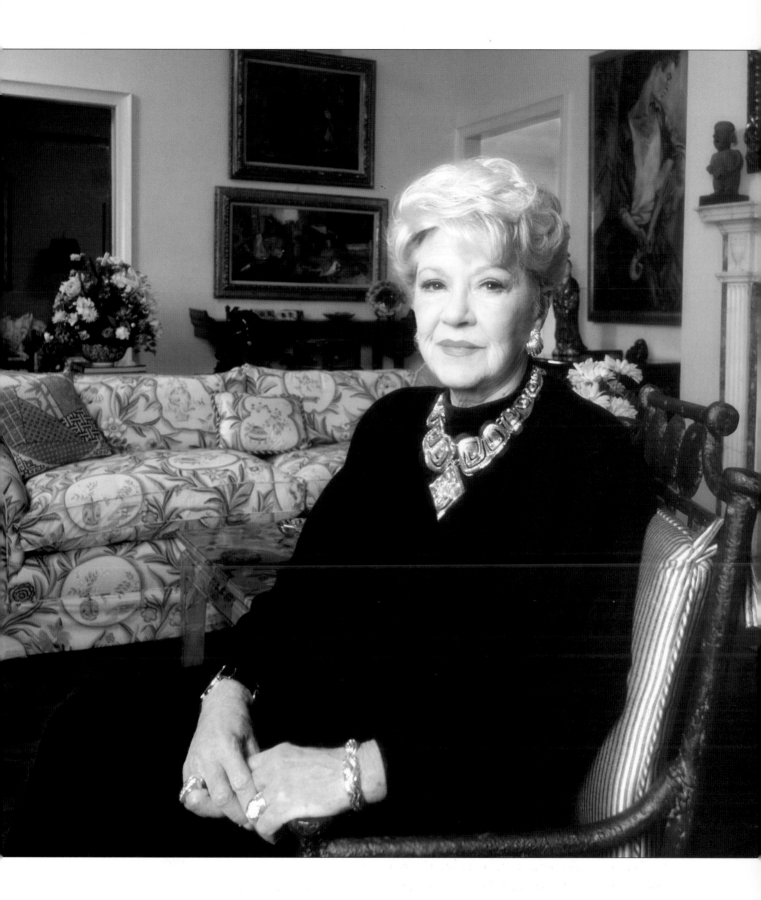

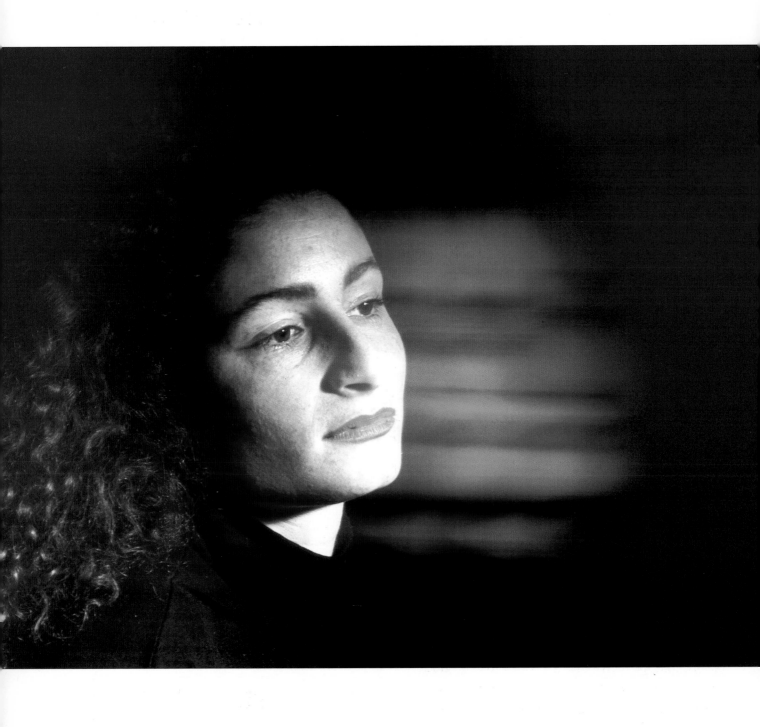

# Outer Sam Pan

**CAMERA:** Hasselblad 503cw

**LENS:** 120mm macro

**FILM:** Fuji RDP

**EXPOSURE:** f/8 at 2 seconds

**LIGHTING:** Comet 1200ws power pack with 30-degree grid for main and 20-degree grid for hair light; Lowell Total Lite

### Assignment

This image was created during a test shot for my portfolio. I was experimenting with motion, strobe, and tungsten light.

### Visual Objective

During this session, I was working to create a dreamy image of my studio manager, Sam Verone.

### Posing

I had Sam tilt her head toward camera and look off into the distance. She stood still while I panned the camera to create the blur effect.

### The Story

I was trying to perfect the motion-blur technique, mixing strobe with tungsten light—and I was fortunate enough to have an exotic-looking studio manager for my subject. I originally shot her against a black background, but it was too clean looking. So I placed green and blue 4 x 8-foot foamcore panels behind Sam with a black gap between them, subtly creating greater visual ambivalence. I felt the test was success, because after experimenting for about an hour I felt more confident about using this technique on an assignment.

### Tips

The best way to challenge yourself as a photographer is to try out a technique that is unfamiliar to you—

something you're not comfortable with. If it makes your heart beat faster and your palms sweat, you know you are on your way to creating something special. Of course, you shouldn't risk your reputation by doing this on the job; test out new techniques on your own time.

I try to do test shots for my portfolio, and for my personal growth as a photographer, once a month. Many of my test shots fail, but every once in a while I have a really great success that washes away all the failed attempts.

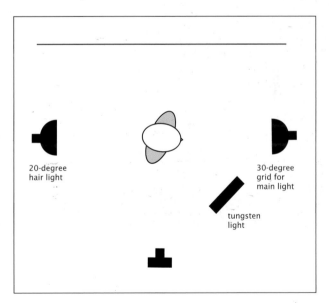

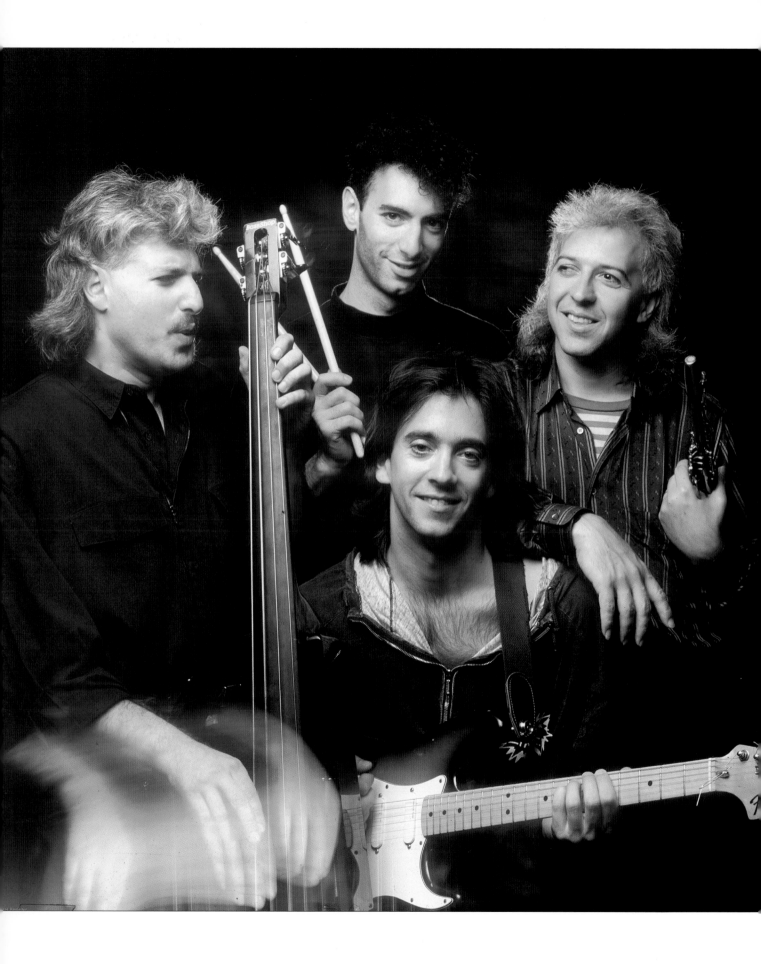

# Motion to Urban Earth

**CAMERA:** Hasselblad 503cw

**LENS:** 120mm macro

**FILM:** Fuji RDP

**EXPOSURE:** f/11 at ⅛ second

**LIGHTING:** two Profoto 800ws power packs; large Plume softbox for main light; 30-degree grid covered by spun glass on background; 20-degree grid with blue gel highlighting drummer and sax player; tungsten light for motion

### Assignment

Jazz bassist Harvie Swartz hired me to photograph his band Urban Earth for their upcoming CD.

### Visual Objective

Harvie wanted a group shot for the back cover of the album—back when it was really a vinyl record. I always think of Picasso's painting *Three Musicians* when I photograph a band, so I initially had in mind a recreation of the painting with a fourth musician . . . but it wasn't working. Instead, I went for a spontaneous moment and tried to capture the joy of hearing Harvie play his bass.

### The Story

I asked the band to come to the studio and play. Unfortunately, they were still recording and were on a tight schedule so I had to have a solid plan for what I wanted. Happily, I had just done a test shoot emphasizing motion (see the previous case study), so I decided to apply this technique. Harvie wasn't sure what I was up to, but when I showed him the Polaroid he loved the idea and we just kept playing.

### Tip

It is great to work with musicians and fellow artists, but it can also have drawbacks. One possible setback is getting too much subject involvement in the creation of the image. It is important to discuss the music and concept, but it is just as important that *you* make the final decision on the direction of the shot.

The other potential setback is financial. If you are working with the band directly, there isn't usually a sufficient budget to produce the "big" shot the band wants. It is up to you how you want to negotiate, but try not to lose money on the shoot. Also be sure to to have a contract between you and the group specifying how the images are to be used. If they have a small budget, limit the usage of the image. Be sure to note in the contract that if the image is used for any additional promotional venues, an additional fee needs to be paid to the photographer.

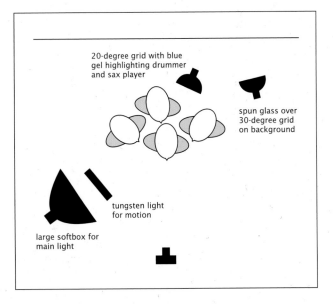

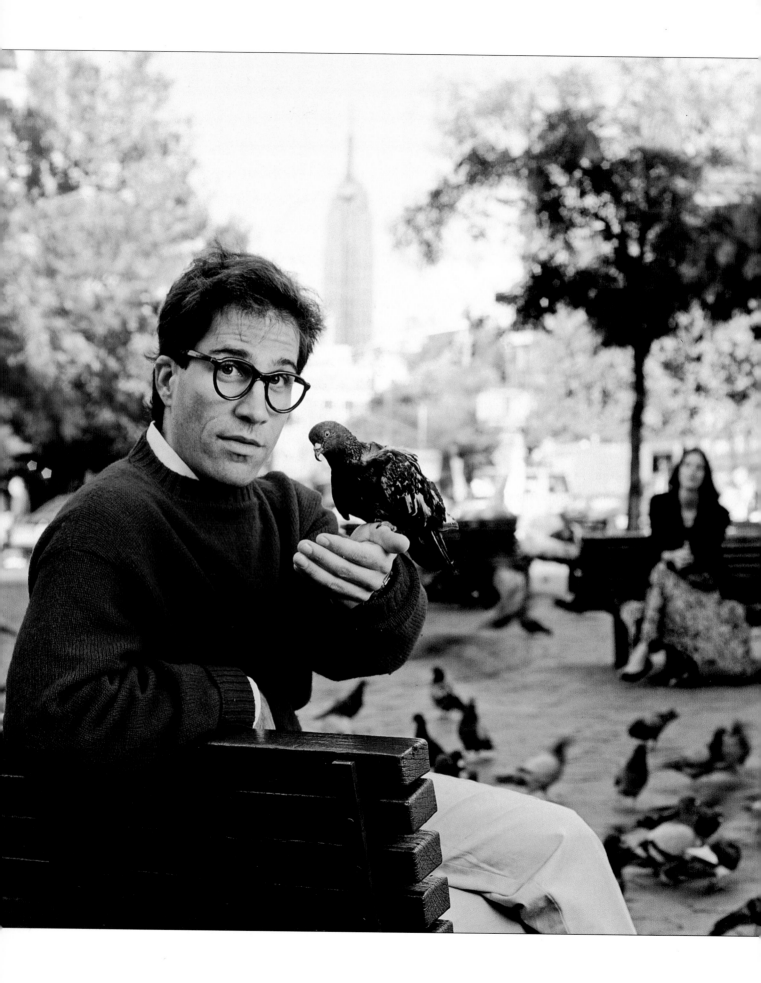

# Woody, Meet Ira

CAMERA: Hasselblad 503cw
LENS: 120mm
FILM: Fuji RDP
EXPOSURE: f/5.6 at $\frac{1}{60}$ second
LIGHTING: Norman 200B
OTHER: 81b filter to warm the open shade

## Assignment

*Ford Times Magazine* assigned me to photograph actors who are stand-ins for famous actors. These are people who literally stand on the set so the cinematographer and lighting crew can get set up before the star arrives. They don't always look like the star, but they have the same build and face shape.

## Visual Objective

I wanted to create a Woody Allen–type of movie still depicting Ira Sakolski, Woody Allen's movie stand-in.

## Posing

Ira was great to work with (did I mention how much fun it is to work with actors?) and had mastered Allen's mannerisms. I had him turn around in the park bench as if it were a candid moment.

## Story

A park across from the Waverly Theater on 8th Street in Manhattan was the perfect location for this shot. You could see the Empire State building and there were always pigeons, the city mascot. We brought a bunch of breadcrumbs to attract more pigeons. While I was shooting, Mr. Sakolsky said, "Watch this." Then, he somehow lured a pigeon to perch on his hand—that was the shot. The one mysterious aspect of this shoot was the woman in the background. No one knew her, but she seemed to follow us to the park and placed herself in the frame. She added an Allen-esque feel to the image, so we kept her in.

## Tips

If you intend to become a location portrait photographer, effectively scouting locations is key to a successful shoot. There are also professional location scouts you can hire when working outside of your familiar turf. I am always looking for interesting locations that I will use for future shoots. Sometimes it also works the other way around; a great location will inspire me to create a portrait shoot.

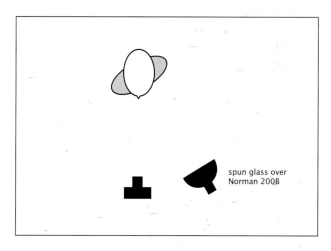

spun glass over
Norman 200B

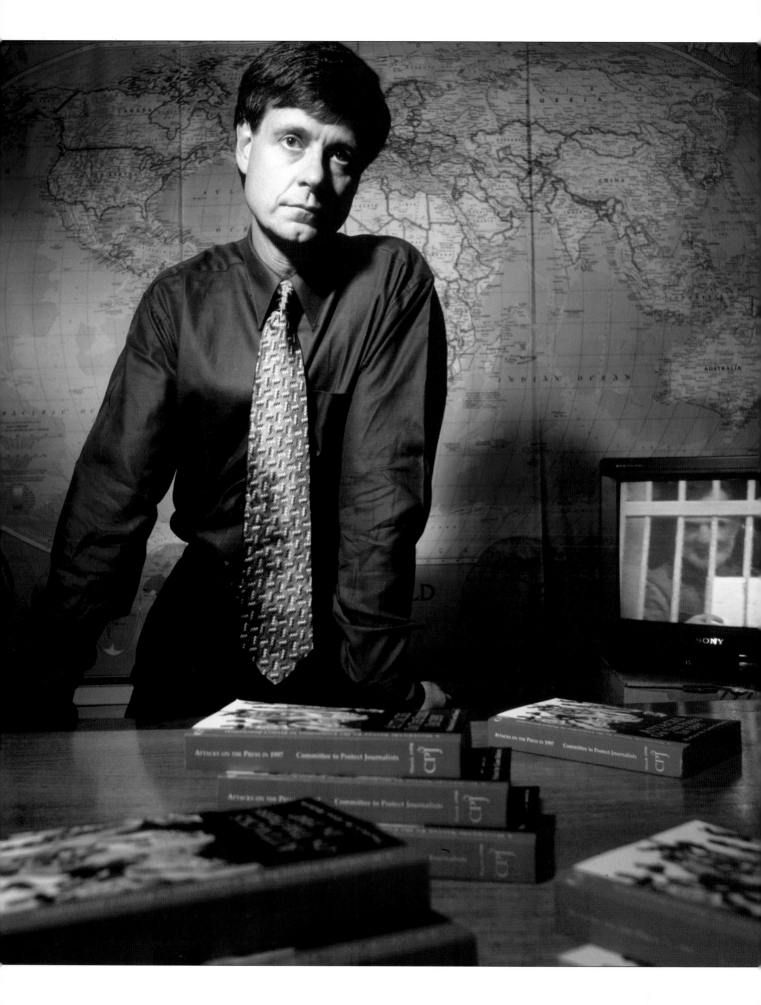

# Protecting Journalist

**CAMERA:** Hasselblad 503cw

**LENS:** 50mm

**FILM:** Kodak EPP

**EXPOSURE:** f/8 at $^1/_{15}$ second

**LIGHTING:** two 800 Profoto packs; 30-degree grid as main light; two heads with black-wrap gobos on map (one with blue gel, one with green gel)

## Assignment

I was assigned to photograph William A. Orme, Jr., a journalist and the former director of the Center for the Protection of Journalists (CPJ), for the McCormick Tribune Foundation Annual Report.

## Visual Objective

A serious subject requires dramatic lighting. Additionally, I wanted to show the global reach of the CPJ organization and the challenges they face.

## Posing

I had Mr. Orme lean toward the camera, supporting his weight with one hand. His other arm was positioned to create a strong diagonal for visual tension.

## The Story

Not-for-profit organizations, often understaffed and on tight budgets, usually have very basic facilities that are uninspiring for portraits. I decided to be inventive in this small conference room, which contained an old world map, some CPJ books, and a video monitor. I pulled out blue and green gels, arranged the books, and asked if there was a video clip I could play to put an image on the monitor. This was one of those moments that you realize the power of lighting and how it can transform the ordinary into the extraordinary. The client was happy with the image and so was the CPJ, who ended up buying a print for their office.

## Tips

The key to getting rich gel color on the desired surface is to isolate the other light sources. Since the main light is directed toward the background, that's the light that usually washes out the color. Using a grid on the main reduces spill, as will placing a gobo between the reflector and the background. The result is a richer gel color on the background.

Alternately, if you have the luxury of working in a large space, then distance is your friend. Placing the key light far enough away from the background will also prevent wash-out of the background color. The best way to test this is by metering your background without the key light and with the key light, if there is no difference in the reading, you are good to go.

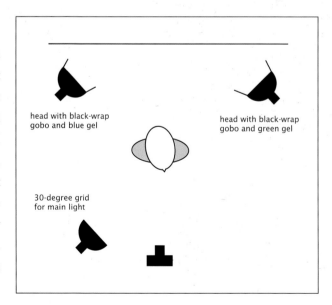

head with black-wrap
gobo and blue gel

head with black-wrap
gobo and green gel

30-degree grid
for main light

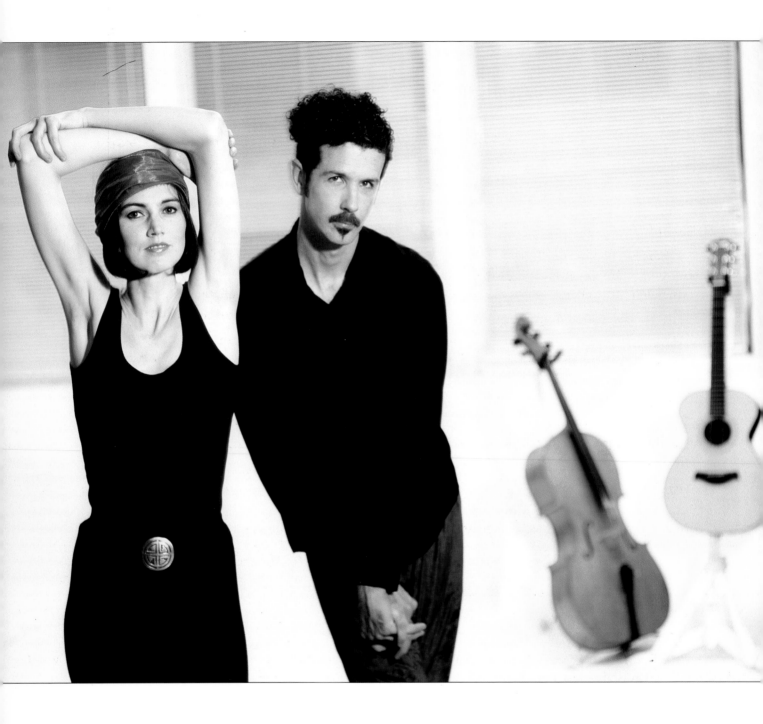

# Not So Nude

CAMERA: Hasselblad 503cw

LENS: 120mm

FILM: Fuji RDP

EXPOSURE: f/5.6 at $^1/_{125}$ second

LIGHTING: Luz 800ws pack with large Plume light bank; Luz 800ws pack with two heads bounced off ceiling behind subjects (heads fitted with yellow gels and gobos to prevent spill on subjects)

### Assignment

I was hired by The Nudes (Walter Parks and Stephanie Winters) to photograph them for promotion of their forthcoming music CD.

### Visual Objective

I wanted to create warm, whimsical images of the duo.

### Posing

This pose was spontaneous. I had set up the cello and guitar in the background with the idea of posing Walter and Stephanie in a similar fashion. It looked forced, so I asked if they would stand in place and just move their hips and arms and stare into the lens. I started shooting and let them strike their own poses.

### Story

One of the band's songs was called "Arizona," and I wanted to incorporate that in the photo. I was thinking cactus, sun, desert, etc.—but since there wasn't any budget to work with, I had to keep it simple, I thought yellow, and instead of cactus, guitar and cello. Adding to the theme is Stephanie's Hopi belt buckle. The image was never used for their CD, but a music magazine ended up using it for their cover.

### Tip

I often work with little or no budget when photographing artists. This forces me to improvise and in-vent. I have actually had some of my best photo sessions when working under those conditions.

It is great when the client has a big budget, but in some ways it can also be inhibiting. There is an underlying tension in your subconscious mind that keeps telling you, "Wow, the client is giving me all this money to create a brilliant photo—I'd better perform." I have found that I get better results when I brush that thought aside and instead think, "I'd better have fun doing this shoot or why bother?"

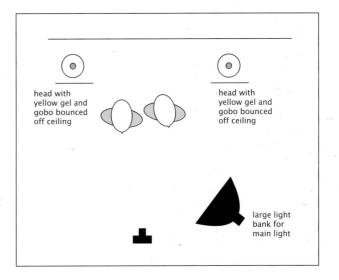

head with yellow gel and gobo bounced off ceiling

head with yellow gel and gobo bounced off ceiling

large light bank for main light

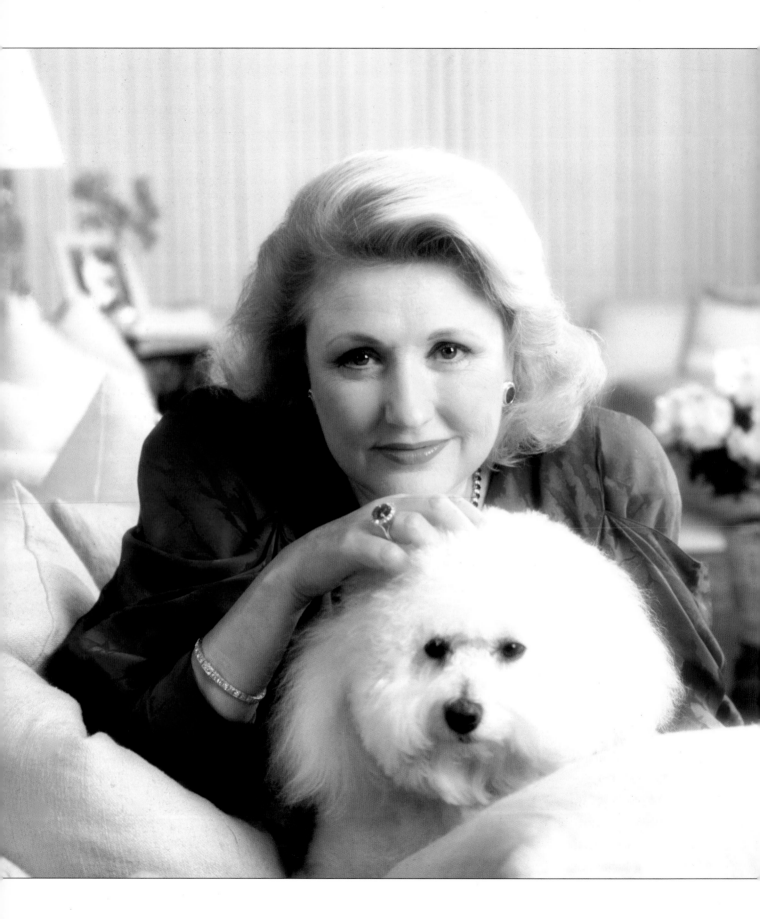

# First Lady of Fiction

**CAMERA:** Hasselblad 503cw
**LENS:** 120mm macro
**FILM:** Fuji RDP
**EXPOSURE:** f/5.6 at $^1/_{125}$ second
**LIGHTING:** two Luz 800ws packs with three strobe heads; medium Chimera softbox as main light; fill lights bounced off low white ceiling
**OTHER:** Softar II filter

### Assignment

I was asked to photograph the author Barbara Bradford Taylor for a series on celebrities and their pets for *Modern Maturity* magazine. This was a fun series that sent me around the country photographing celebrities at their homes.

### Visual Objective

To create an image that portrays success and wealth.

### Posing

I felt that positioning Ms. Taylor on the couch and turning her torso toward camera would allow her to sit comfortably while handling her dog, Gem. It also allowed me to shoot at a downward angle and have her look up to widen her eyes,

### Story

The living room in Ms. Taylor's Upper East Side apartment was mirrored, wall-to-wall, with gold trim. My first response was, "How am I going to light a mirrored room?" Thankfully, the back wall was a floor-to-ceiling window draped with a pinkish blind. Once my assistant and I set up the lights and arranged the flowers and photos in the background I was ready to photograph Ms. Taylor and Gem. (*Note:* When pets are involved, work quickly; most won't behave for a long shoot.) I limited my shooting to this one setup and shot close and wide. The shoot went well and got a thumbs-up from Ms. Taylor. My only regret was not bringing one of her books with me for her to sign.

### Tip

When you embark on a series of portraits for a client, or even yourself, it is a good idea to establish a style of shooting. Whether it's using a specific type of lens or the same background, this repeated element becomes the visual thread that holds the story together. Establishing a particular style of shooting can also become your marketing vehicle to assignment work. It allows buyers of photography to identify you by the work you produce.

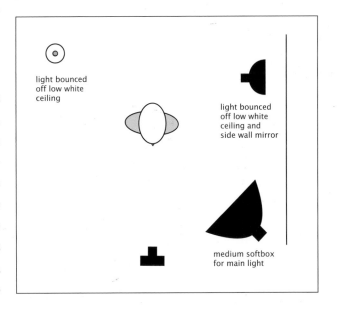

light bounced off low white ceiling

light bounced off low white ceiling and side wall mirror

medium softbox for main light

# Have You Driven a Ford Lately?

**CAMERA:** Hasselblad 503cw
**LENS:** 120mm macro
**FILM:** Fuji RDP
**EXPOSURE:** f/11 at $^1/_{125}$ second
**LIGHTING:** Luz 1200ws with large Chimera softbox for main light; two Luz 800ws power packs with four heads with 30-degree grids and colored gels for background
**OTHER:** Star filter

### Assignment

I was assigned to photograph the singer of the popular Ford jingle for the cover of *Ford Times*.

### Visual Objective

I wanted to create a theatrical look.

### Posing

For magazine covers, I want the subject to have a direct relationship with the lens. I asked Ms. Cisyk to pretend she was on stage and was receiving applause for a song she had just finished.

### The Story

I photographed Ms. Cisyk in her home, riding a horse, and doing other activities around the property. I was looking for an opening shot for the article, lifestyle images to fill out the story, and a cover shot. After a whole day of shooting, though, I realized I didn't really have a cover shot, so I called the editor and requested another day in the studio to create the cover shot. She understood and budgeted another day of shooting.

For the studio shot the next day, my assistant and I set up a simulated stage shot. I shot a test roll and sent it to the lab that night to see the results the following morning. When Ms. Cisyk arrived at the studio we were ready. I had her sing the Ford jingle about twenty times and photographed her when she stopped. We shot about two dozen frames and called it a day.

### Tips

When shooting a magazine cover, the art director usually has a concept in mind and will even send over a layout. For this assignment, it was very loose; the editor was probably hoping I would have gotten something at her home. I should have been more direct in asking about the direction of the cover shot—a lesson learned. I did get another day of work out of the assignment, though, and that is a good thing.

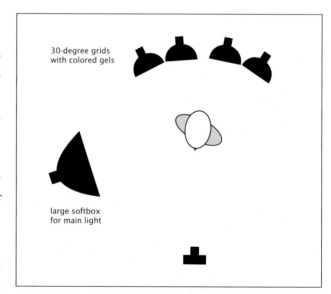

30-degree grids
with colored gels

large softbox
for main light

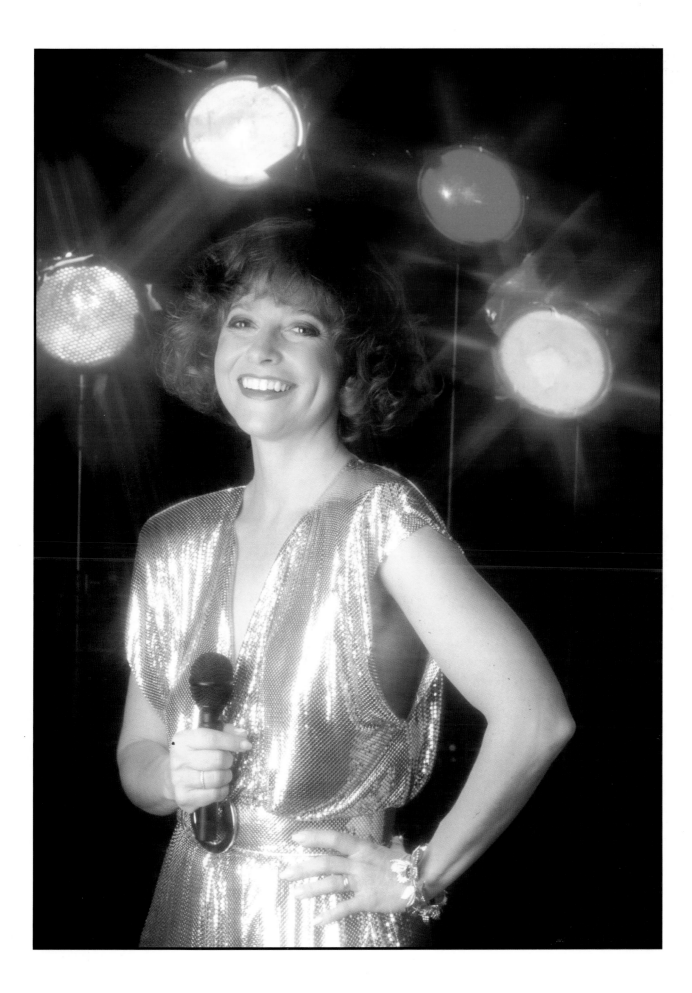

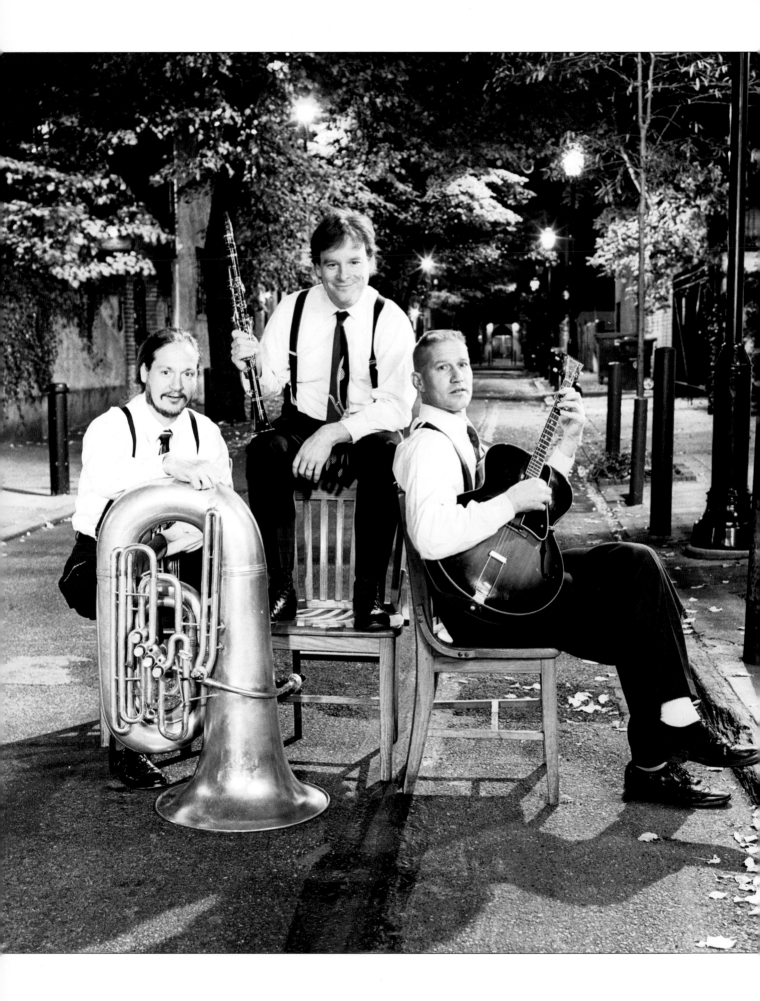

# Hothouse in the Alley

**CAMERA:** Hasselblad 503cw
**LENS:** 80mm
**FILM:** Kodak Tri-X
**EXPOSURE:** f/8 at ½ second
**LIGHTING:** Profoto Acute 800ws pack with strobe head and large Plume softbox

### Assignment

I was asked to photograph the trio Hothouse, a swing and Dixie band, for publicity and their upcoming CD.

### Visual Objective

Although shot in Philadelphia, I wanted to create a late-night New Orleans style.

### Posing

I started with the classic golden triangle composition. I positioned the tuba player and the guitar player first. Then I had the clarinet player balance on the chair to create the top of the triangle.

### The Story

Before the shoot, tuba player Eric Henry gave me the CD so I could get some ideas for the shot. Immediately, I thought "New Orleans nightlife." In my scouting, I came across this alley behind a restaurant called Magnolias (where, ironically, they served New Orleans cuisine). It seemed like the stars were aligned.

We all met at the restaurant, whose proprietor was happy to help with the shoot, and took some bar chairs to the alley. While I positioned the musicians, my assistant set up the light. I then set the camera on the tripod, plugged in my cable release, metered the light, and I shot a Polaroid. The Polaroid looked good, but I played around with the shutter, speed slowing it down to bring in more ambient light.

We were moving right along when suddenly I saw police lights flashing in the background. The police asked us to move because we were blocking the alley and did not have a permit for the shoot. They were right, so we stopped. Besides, I knew I had the shot.

### Tips

For night shoots, be sure to pack a cable release. This will help prevent camera shake, and it lets you look at your subjects directly (not through the viewfinder) so you can talk to them while you snap away.

Also, get a permit from the city (either at the film office or city hall) to photograph on the street. In almost all public spaces, when you put down a tripod you need a permit.

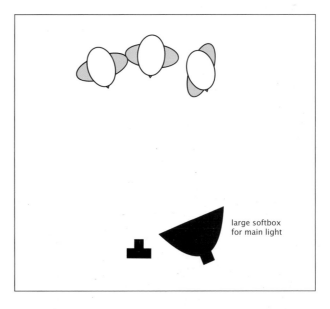

large softbox for main light

# Vignelli Design

**CAMERA:** Hasselblad 503cw
**LENS:** 120mm macro
**FILM:** Fuji RDP
**EXPOSURE:** f/8 at ¹/₁₂₅ second
**LIGHTING:** Profoto 800ws pack with one head and spun glass over 40-degree grid for the main light; Profoto 800ws pack with two heads (one with 20-degree grid as hair light; one with 30-degree grid on background)

### Assignment

Massimo and Luca Vignelli, who seemed to have a very close, respectful relationship, were photographed for my *Fathers and Sons* book.

### Visual Objective

Massimo Vignelli and Associates is a well-known design firm that has created timeless packaging designs, corporate identities, and other graphics—including the New York City subway map. I wanted an environment that reflected their sense of design.

### Posing

I posed Massimo to act as a visual anchor to his son, leaning against the doorframe. I asked Massimo to throw his arm over Luca's shoulder and for Luca to lean into him. I wanted them to seem connected.

### The Story

When I arrived at the Vignelli and Associates offices on the west side of Manhattan, I was in awe of the postindustrialist design, featuring contemporary furniture and walls of polished steel or stark white. I was also delighted to see that the Vignellis were both dressed in black and striking to look at. All I had to do was set up the right type of light. Because the environment suited the subjects and they were totally into having the photo taken, it was one of the easiest and most natural shoots I have ever experienced.

### Tips

One of the reasons I enjoy environmental portraits is because the environment often reflects the subject's personality. The ability to identify such environmental elements is an important skill to develop. If you do it successfully, the environment will complement your subject and not compete with them. In this image, for example, the environment is monochromatic, drawing your eyes immediately to their faces.

I cannot overemphasize the need to match the light with the subject. In this image I felt that Hollywood-style lighting would work the best. I used hard lights to bring out the angles of their faces. It also creates a little drama with the shadows and geometric shapes.

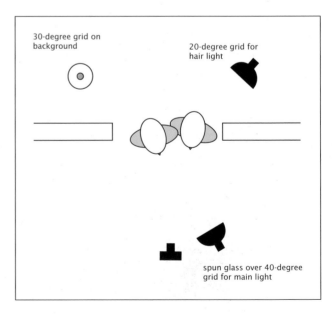

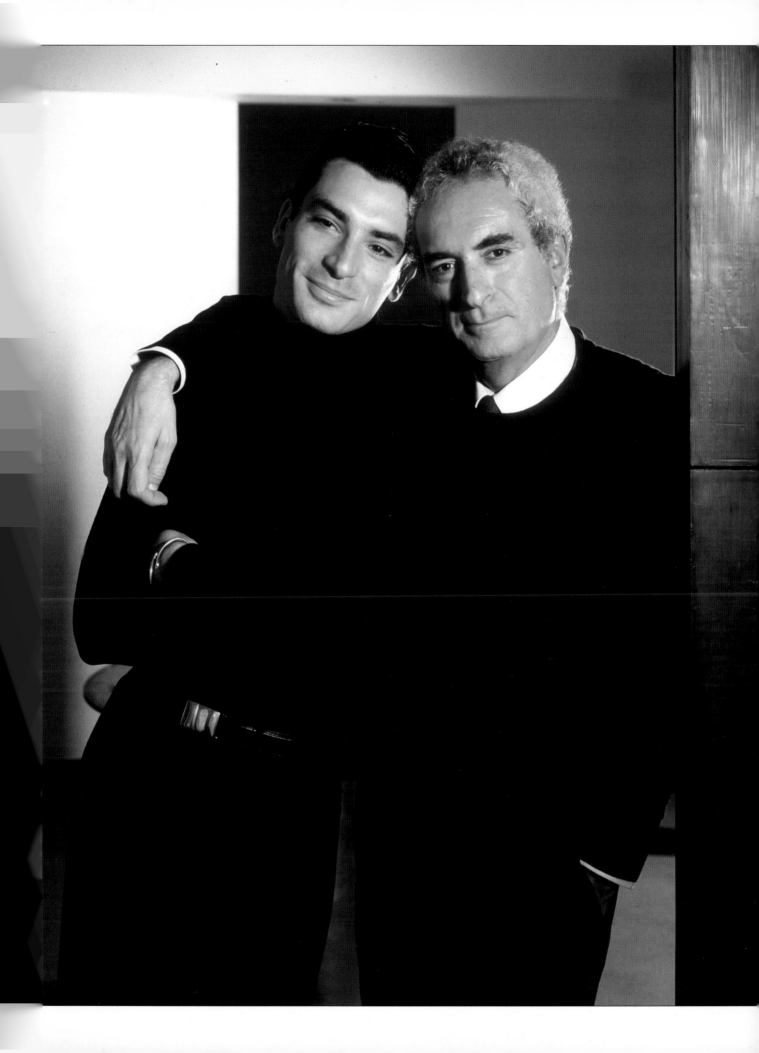

# In the Met

**CAMERA:** Hasselblad 503cw
**LENS:** 50mm
**FILM:** Fuji RDP
**EXPOSURE:** f/8 at ¼ second
**LIGHTING:** Profoto 800ws pack with one medium Plume softbox

### Assignment

I photographed Arthur Ochs "Punch" Sulzberger for a *Manhattan Inc.* article about the chairmen of New York art institutions. At the time, Mr. Sulzberger was chairman of the Metropolitan Museum of Art.

### Visual Objective

I wanted to capture a portrait that reflected a sense of power and tradition.

### Posing

For the mood I had in mind, it made sense to have him cross his arms. Sometimes, crossing the arms can suggest defensiveness, but here it looks relaxed.

### The Story

For this shoot, I was allowed to scout the MMA after closing. Even though I had found the location early on in my scouting I spent an extra hour looking around—what a treat!

Since Mr. Sulzberger was sort of a patron saint, having raised millions for the art museum, I positioned him so a halo appeared to frame his head. (*Note:* Because I forgot my stepladder, I had to step on one of my strobe cases to get the right perspective.) Rather than try to illuminate the columns or shoot tungsten film and convert my strobe light, I decided to drag my shutter and let the background go gold, which implied wealth.

### Tips

This assignment was generated because of a paper trail. The magazine had lost three slides from a previous job, but I had included a contract stating that if any slide was damaged or lost, a $1,500 fee would be paid to me for each. I had a good relation with this publication, so rather than demand the money I requested a trade; I would accept another photo assignment of equal value. The client was more than happy to oblige and I got this great assignment (plus, I continued to work with this client until they folded). Whenever you send out materials, you should keep a record of who they went to and include a Rights and Usage agreement if the client intends to publish the work.

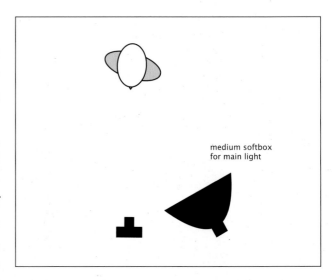

medium softbox
for main light

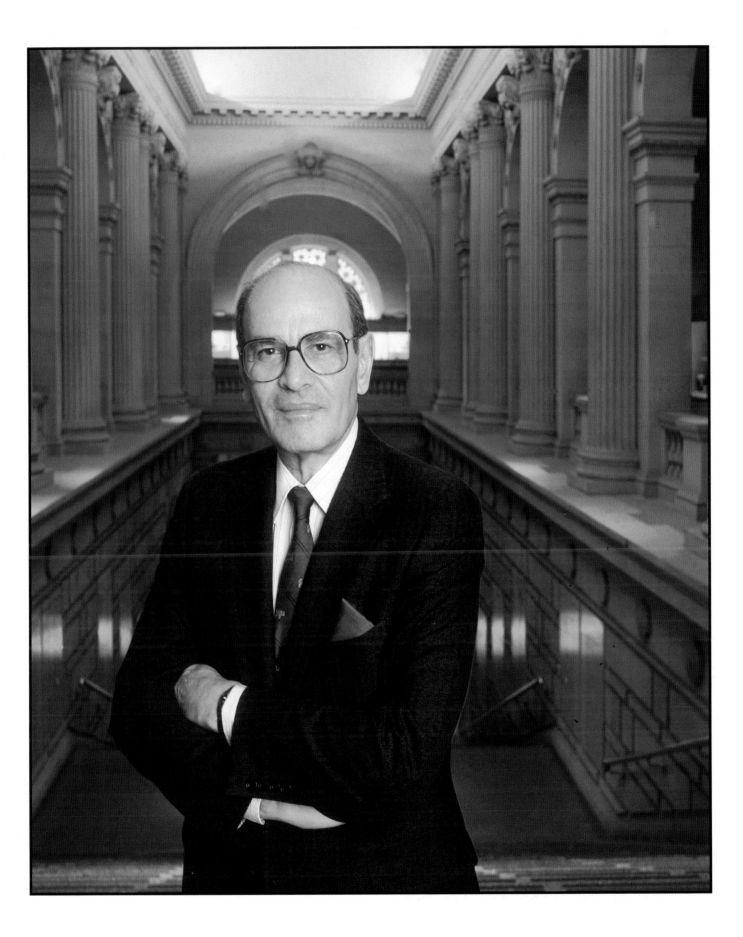

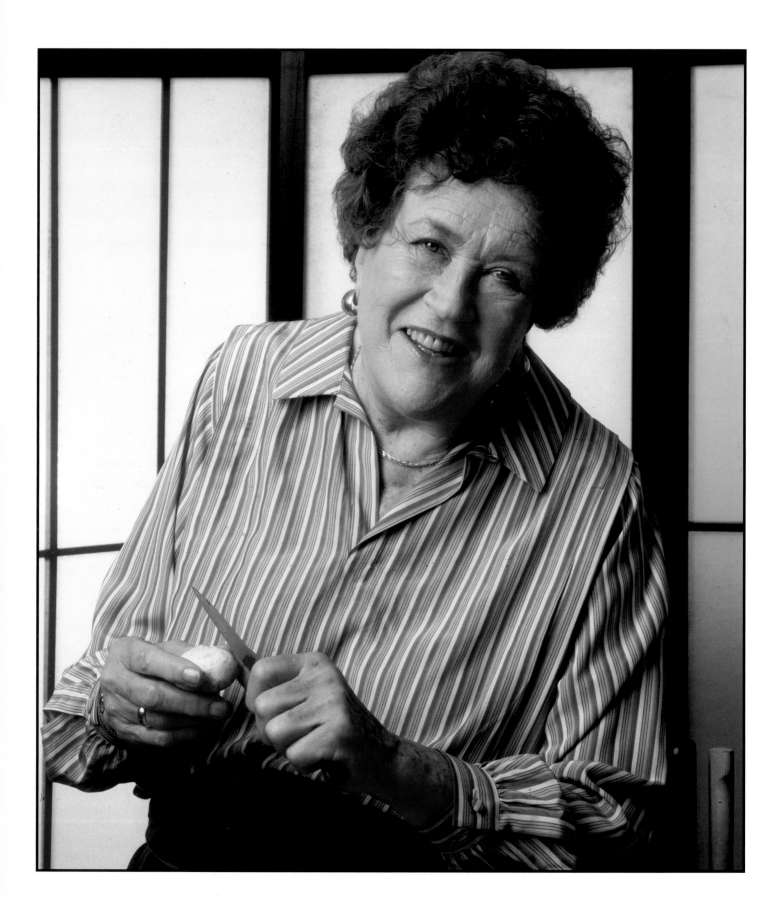

# Julia's Kitchen

**CAMERA:** Hasselblad 503cw

**LENS:** 50mm

**FILM:** Fuji RDP

**EXPOSURE:** f/8 at $^1/_{125}$ second

**LIGHTING:** medium Plume softbox for main light; two background lights through rice paper screen (one with red gel, one with blue gel)

## Assignment

I photographed Julia Child at her home in Santa Barbara for the cover of *Modern Maturity* magazine.

## Visual Objective

I wanted to capture the famous chef's flamboyant personality and a simple indication of her vocation.

## Posing

Although the publication used another image for the cover (showing more of the kitchen), I have always liked this one. She is turned to the camera with her left shoulder dropped, simply paring a garlic clove. Julia put on her charm and was great in front of the camera, striking a different pose in almost every frame.

## Story

I flew to California, where I met up with an assistant hired via the American Society of Media Photographers (ASMP) resource list. We packed a rental car and drove to Santa Barbara where Julia greeted us with all her warmth and charm.

The kitchen was the obvious backdrop for the portrait, but it was (ironically) small. So, while we placed our lights, I set up a partition to hide the kitchen mess. I then used my wide-angle lens to capture more of the environment and the six-foot chef.

At the end, Julia invited us to stay for dinner—one of the best on-the-road meals I had ever eaten.

## Tips

Although travel can be fun, it can also be physically exhausting and costly. In years past, photographers could tip the sky cap $20 and curbside their luggage, avoiding excess baggage charges. Today, having a professional rental house like Calumet ship the equipment to the shoot is a better option and often cheaper than paying for excess baggage—especially if you are traveling solo. Just make sure you clear the extra expense with the client. That said, I never check my cameras; I always carry them on board. That way, if the airline loses my luggage—and they have—I always have my cameras. Worst-case scenario? I shoot natural light.

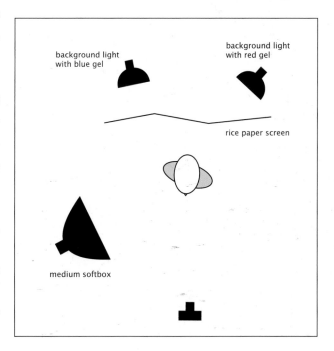

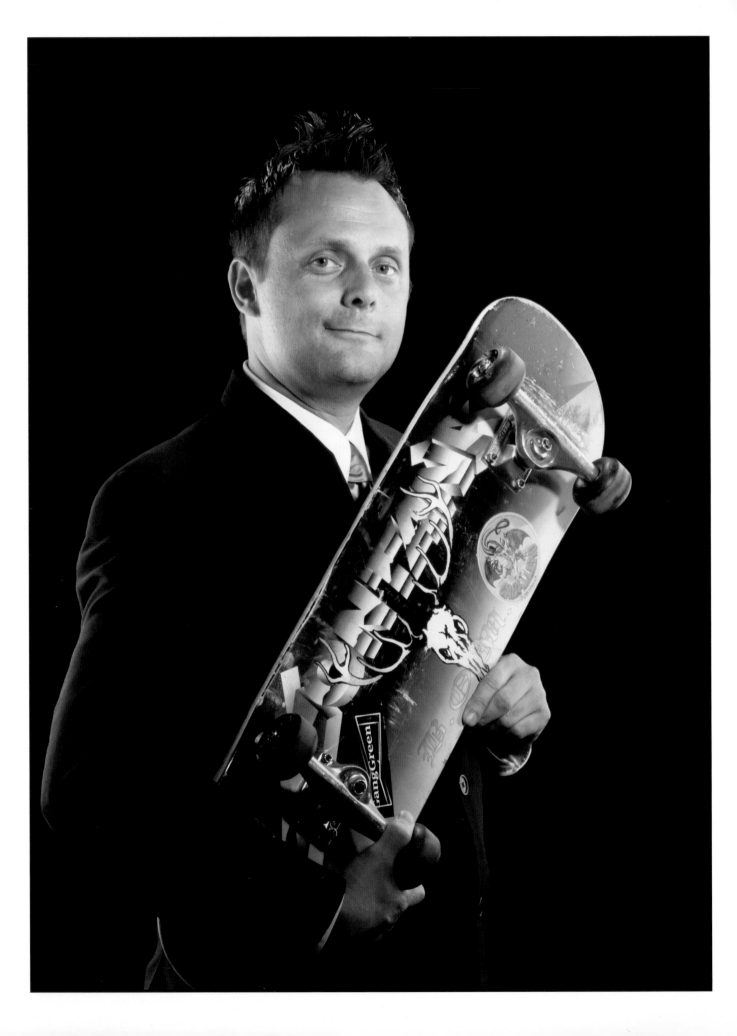

# Computers and Skateboards

**CAMERA:** Canon D30

**LENS:** 58mm focal length

**EXPOSURE:** f/19 at ¹/₁₂₅ second

**LIGHTING:** Profoto 800ws head with large Plume softbox for main light; another head placed in front of softbox with 40-degree grid; Profoto 800ws pack with 30-degree grid on boom for hair light; Profoto 1200ws pack with two medium Plume softboxes for side lights

### Assignment

This portrait of Craig Flint, owner of Computer ER, was shot for the cover of *Channel Advisor* magazine.

### Visual Objective

I wanted to create an edgy, contemporary portrait. I had noticed a trend toward strong rim lighting and wanted to emulate that style.

### Pose

Magazine covers can be restrictive when it comes to posing. The subject needs to fit within a strong vertical frame, and there need to be extra space above the subject for the masthead. In this case, the photo editor was planning to drop in a background, so Craig's position was predetermined by the layout.

### Story

You never know where a job is going to come from. I received this job from a photo editor, Stacy Pleasant, I used to work for in the '80s. She came across my name on the Internet when looking for photographers in Montana. The story got even stranger: the assignment was to photograph the owner of the company that services my computer. The site was a five-minute drive from my studio and Craig and his wife are actually friends—talk about a stress reliever!

I knew Craig was totally into skateboarding, but I also knew that the editor would not want that shot.

So I had him hold the board only for a few final shots. I submitted all the variations, but (as predicted) they used the one without the skateboard.

### Tips

I cut out magazine images that appeal to me and file them away. Periodically, I go through the file to see if I want to apply any of the lighting techniques to my images. It is important to stay current and keep your work up to date. When you trying to catch the attention of a new client, they are always looking for something "different."

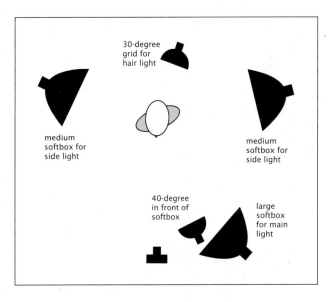

30-degree grid for hair light

medium softbox for side light

medium softbox for side light

40-degree in front of softbox

large softbox for main light

# Piper's Daughter

**CAMERA:** Hasselblad 503cw
**LENS:** 120mm macro
**FILM:** Fuji RDP
**EXPOSURE:** f/8 at $\frac{1}{60}$ second
**LIGHTING:** Profoto 800ws pack with one medium Plume softbox

### Assignment

Traveling to Los Angeles for a "mothers and daughters" project, I was fortunate to have a session with Piper Laurie, an Emmy-winning and Oscar-nominated actress, and her daughter Ann Grace.

### Visual Objective

As in my "fathers and sons" project, each portrait was taken in the family's environment. I also looked for a simple background, one that would imply a home but not distract from my subjects.

### Pose

When I photograph pairs, I like them to get close and touch. Here, I had them both standing and placed a tall pedestal in front of Ms. Laurie to lean on. I then asked Ann Grace to wrap her arm around her mother and intertwine their fingers. This was the primary pose that I used for most of the session.

### The Story

Nothing really struck me inside the home as an ideal background, so I took a look in the backyard. There, I saw a simple white fence that I thought would compliment their black outfits. Once they were posed, I asked Ms. Laurie to remember what it was like to be a young mother, a professional actress, and take care of Anne Grace. She closed her eyes and smiled while Anne Grace watched. That was the shot.

### Tips

Wardrobe can make or break a portrait. In styling any portrait with more than one subject, be sure that what they are wearing does not clash. Black is always the classic color, but it may look too serious for your subject. Stay away from busy patterns and clothes that are wrinkled. You want to draw attention to your subjects face not away from it. It is a good idea to ask your subject to bring several outfits—and if you plan to do a lot of studio portraits, invest in a clothes steamer.

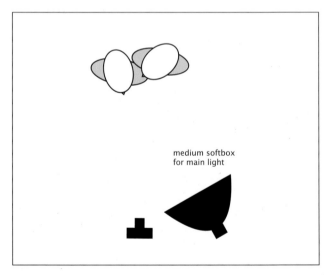

medium softbox
for main light

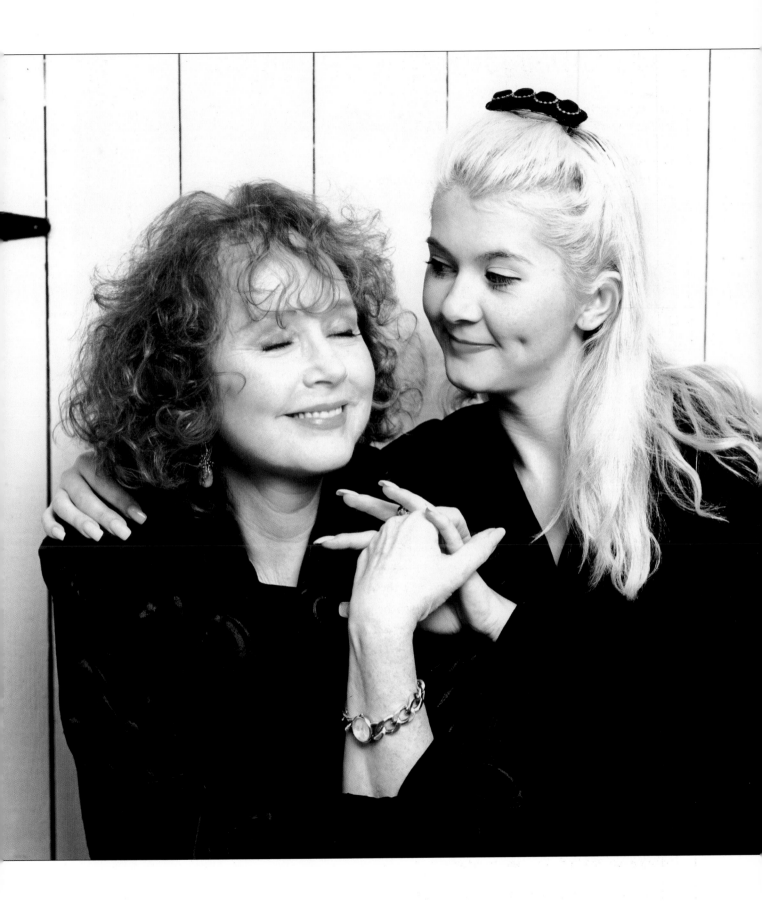

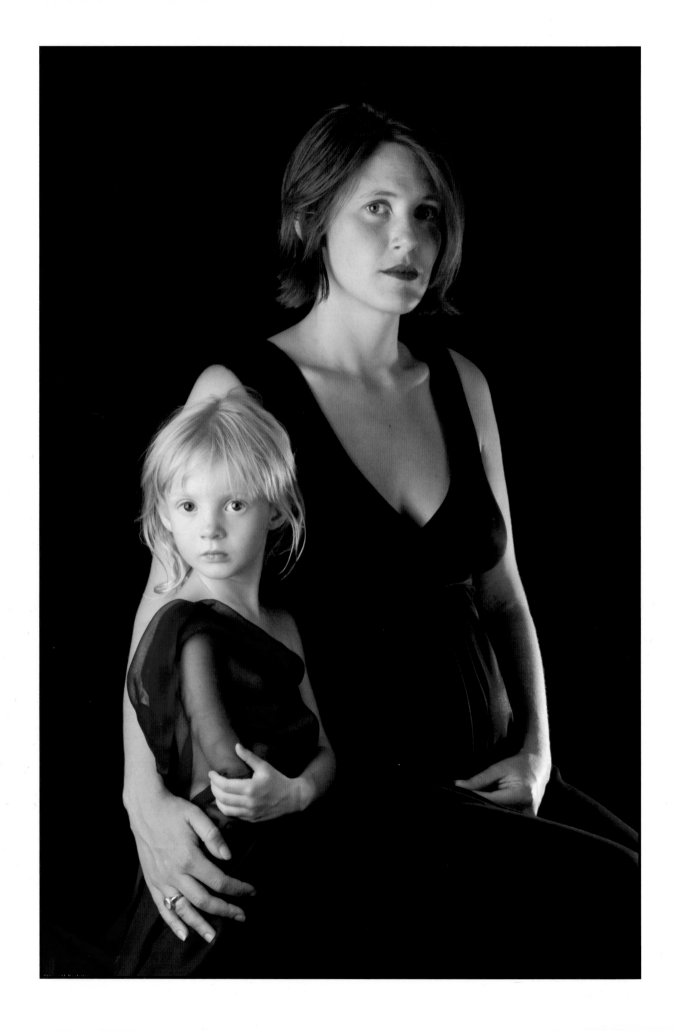

# Grace

**CAMERA:** Canon D30
**LENS:** 24–105mm zoom
**EXPOSURE:** f/11 at ¹/₁₂₅ second
**LIGHTING:** Profoto 800ws head with medium Profoto octagon softbox as main light;
Profoto 800ws head with spun glass over 40-degree grid for rim light

### Assignment

I offered my services to photograph Claire and her daughter Grace for a fashion benefit raising money for a center that helps children with attachment disorders. The image would be used for ads and a poster.

### Visual Objective

The portrait was for a serious cause so I wanted my subjects to appear somber. Still, I felt that the image also had to reflect bonding and warmth, so it needed a softer edge—and to show Claire's maternal nature.

### The Pose

I had Grace stand straight and stare at the camera holding her elbow with her hands—a serious look for a child. I asked Claire to hold her pregnant belly and wrap her other hand around her daughter.

### The Story

Claire owned a fashion boutique so I asked if she would bring a change of clothing and colorful scarves. When they arrived at my studio I was thrilled—Claire was attractive and very pregnant and her daughter was stunning. I had set up a mattress for them to lie down on, since the client asked for a horizontal for the poster. I also chose a black background to isolate the subjects, and knew I had to light them to stand out. Looking at the wardrobe choices, I chose a black dress for Claire and a red scarf to wrap Grace in.

The session went so well that I decided to shoot a vertical shot (seen here) for myself. After switching the red scarf for a purple one, I had Claire sit on a posing stool and placed Grace in front of her.

### Tip

The image of Claire and Grace appeared all over town and part of the exchange was that my web site was printed on all the posters. When you take on gratis work, be sure that your name/web site appears on the posters, brochures, ads, etc.—otherwise there will be no benefit to you. It's also a good idea to get the agreement in writing, so there isn't any confusion about where and how your name will appear.

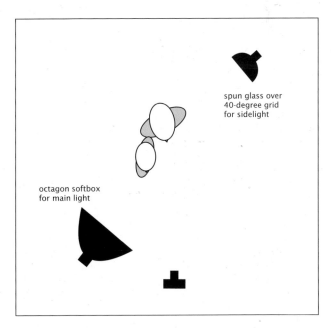

spun glass over
40-degree grid
for sidelight

octagon softbox
for main light

# Adoption Day

**CAMERA:** Canon D30
**LENS:** 24–105mm at 50mm
**ISO:** 100
**EXPOSURE:** f/19 at $^1/_{180}$ second
**LIGHTING:** Profoto 800ws pack with one Profoto octagonal softbox

### Assignment

I photographed my daughter, Metika, for our adoption notice.

### Visual Objective

I wanted to capture Metika's beauty within the context of her birth country, Nepal. So she was dressed up in a top from Bali with a scarf over her head.

### The Story

I had just finished a session the previous day of portraits on black, so I decided to keep the setup. My daughter had never been professionally photographed, so I first photographed my son, Makhesh, so Metika could watch and get used to the process. Then we put them together on the set, which didn't go very well.

So, I pulled my son out of the frame and tried all my kid-tested tricks to get her attention. It was going pretty well, for a two-year-old, until we decided to put the scarf on her head. She immediately started taking it off, but I kept shooting.

It was an exhausting session and I wasn't sure I had captured anything good. Then, I processed the images in Adobe Lightroom and, to my relief, saw this image. It was unexpected, but it worked.

### Tips

When photographing babies and toddlers you need to have patience and be ready at all times. You also have to create a secure and comfortable environment. For instance, I have found that placing a thin foam pad under the baby keeps them in place (or at least softens the tumble). I also play soft classical music to stimulate their senses.

The lighting setup should also accommodate the child's movement. One large softbox and a reflector card for fill works well. This allows the subject to move around on the set without any change in exposure.

Lastly, you need something to grab their attention. I ask the mother to bring in some of their favorite noise-making toys. When I want to attract the child's attention, I simply raise the toy above the camera and squeeze, shake, or rattle and roll.

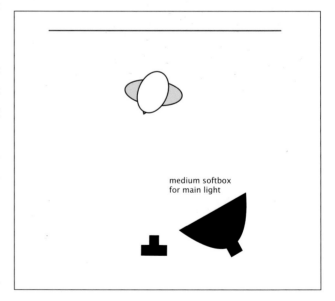

medium softbox for main light

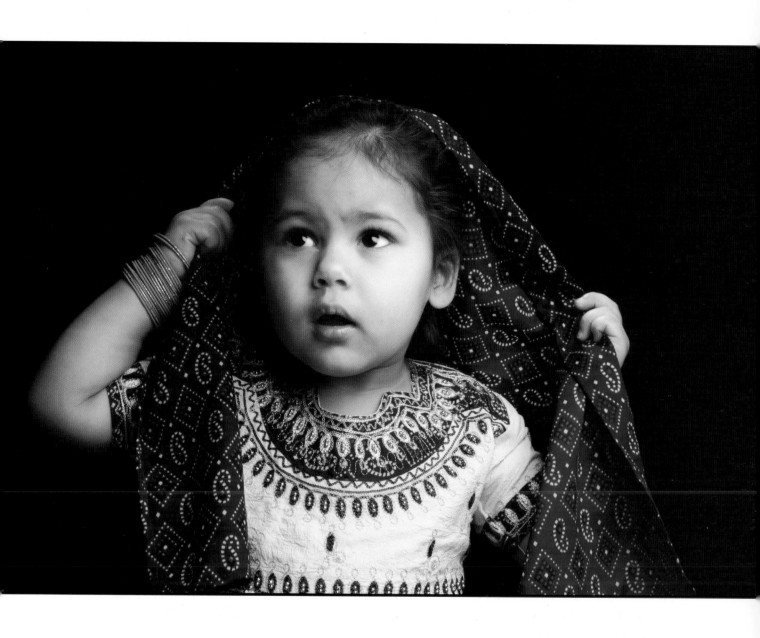

# The Conductor

**CAMERA:** Canon D30

**LENS:** 24–105mm at 105mm

**ISO:** 100

**EXPOSURE:** f/19 at ¹/₁₂₅ second

**LIGHTING:** Profoto 800ws pack with medium Profoto softbox as main; additional light with 30-degree grid placed in front of main light; large white reflector for fill; Profoto 1200ws powering 40-degree grid on boom as hair light and light with spun glass over 40-degree grid on backdrop

### Assignment

I was assigned to take a promotional portrait of Darko Butorac the new conductor of the Missoula Symphony Orchestra (MSO).

### Pose

For a traditional pose of the conductor, I had him sit on a posing chair and place his arms on an Impact posing table. With his arms crossed, I worked on having him change his expressions from serious to big smiles.

### The Story

I got a call from a design firm to see if I was interested in photographing the new conductor of the MSO. Marlene Hutchens, the designer, said, "I can't tell you who he is or how much we can pay you until after the shoot." She did say it would be an image that would be published a lot and would be good exposure for me. I trusted Marlene's judgment, so I said yes. (*Note:* The MSO's search for a new conductor had gone on for three years, and this was their way of keeping the decision a secret until the big announcement.)

My assistant and I set up the studio that morning and, literally ten minutes after the announcement, Darko was in my studio. He was exuberant to find out he was selected and it showed in the photo session. The portrait you see here was used for the program and on the web site.

### Tips

It was a bit of a financial risk to take on this assignment but I felt the subject was interesting and it was a chance to get my name out into the community. I negotiated for my web site address to appear on all published images and had the MSO put a link on their web site to my web site. This agreement was all put in writing and signed by both parties. To make it an equitable trade-off, I also asked for two season tickets. They agreed to all the terms and seemed very happy with the results. Bottom line: Think about all the benefits of taking the photograph, not just monetary ones.

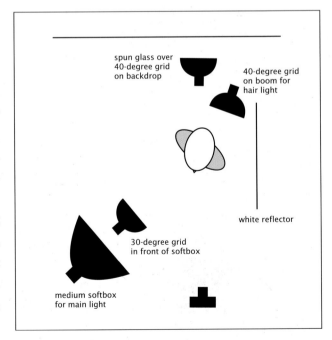

spun glass over
40-degree grid
on backdrop

40-degree grid
on boom for
hair light

white reflector

30-degree grid
in front of softbox

medium softbox
for main light

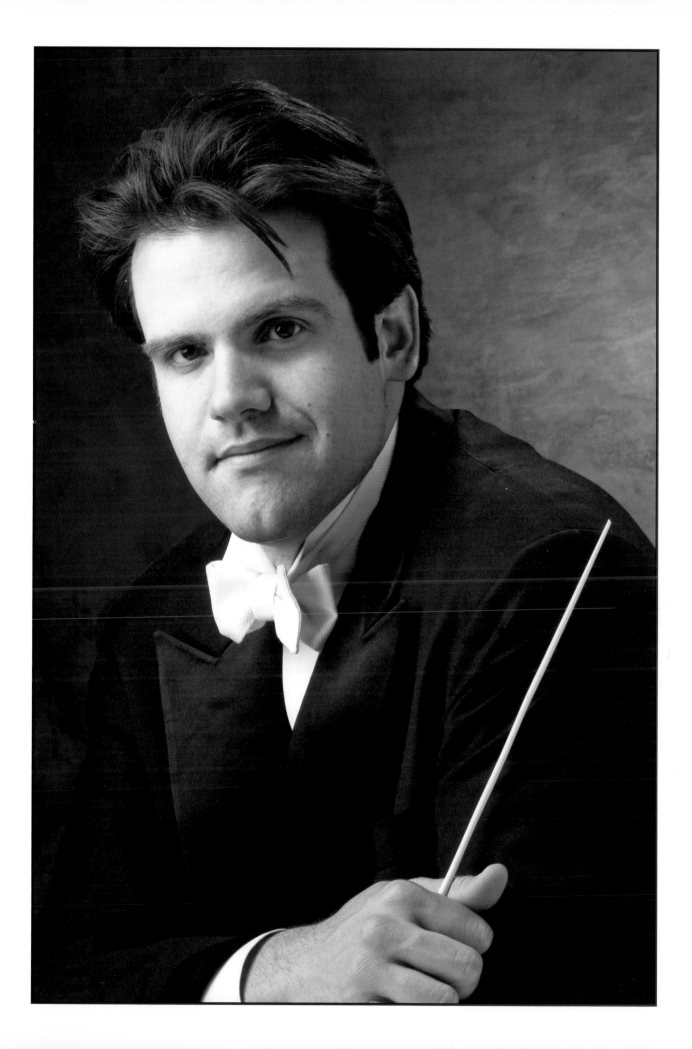

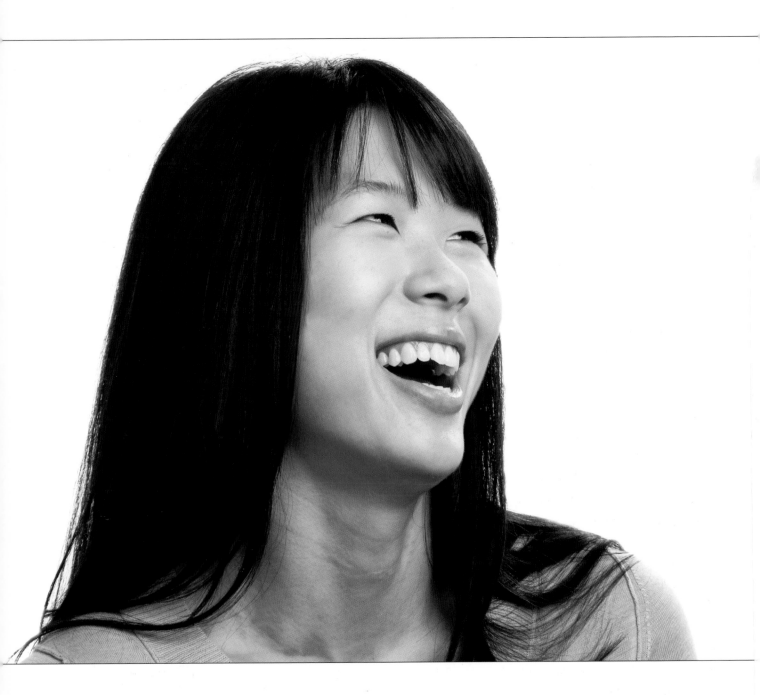

# ExcelleRx

**CAMERA:** Canon D30
**LENS:** 24–105mm zoom at 100mm
**EXPOSURE:** f/11 at $^{1}/_{125}$ second
**LIGHTING:** Profoto 800ws head with medium Plume softbox as main light; Profoto 800ws head with 30-degree grid behind the subject pointed at the ceiling; 1600ws pack with two white umbrellas on the white background; black gobos for umbrellas; white reflector for fill

## Assignment

I was assigned to photograph employees of ExcelleRx for a web-based advertising campaign.

## Visual Objective

The goal was to create very warm, happy portraits using clean and "commercial looking" lighting.

## Pose

These were very tight images so my main objective was to capture happy facial expressions. I asked Monica to close her eyes and open them at the count of three while she threw her head back. We did that many times to capture this image.

## The Story

I received a call about this assignment from a Philadelphia client—three months after I had moved to Montana. Fortunately, I decided to ask about the project and the budget; I realized that I could fly round trip, rent equipment, hire an assistant, stay within their budget, and still make a good profit.

For the shoot, I chose the largest conference room they had and asked them to clear out all the furniture before I arrived the following morning to set up a commercial studio. The biggest challenge here was to contain the light; all the walls were white and the ceiling was at about eight feet. To do this, we used black cards to gobo and model the lights.

Monica was great to work with and looked great in the camera, but she kept saying she didn't photograph well so I decided to play off that insecurity. I joked with her that she needed dental work and to curl her hair if she wanted to become a top fashion model. She turned her head and laughed and that was the shot.

## Tips

It is always a challenge to photograph "real people" in the corporate environment, but it helps to warm them up by greeting them cheerfully and engaging them in conversation about their lives. Don't spend the session looking at your LCD screen; this is the fastest way to disengage from your subject and remind them that they are being photographed.

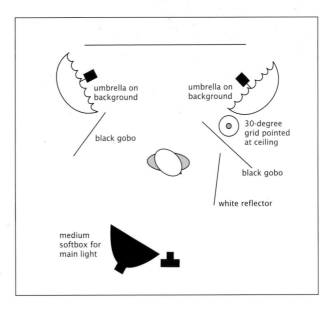

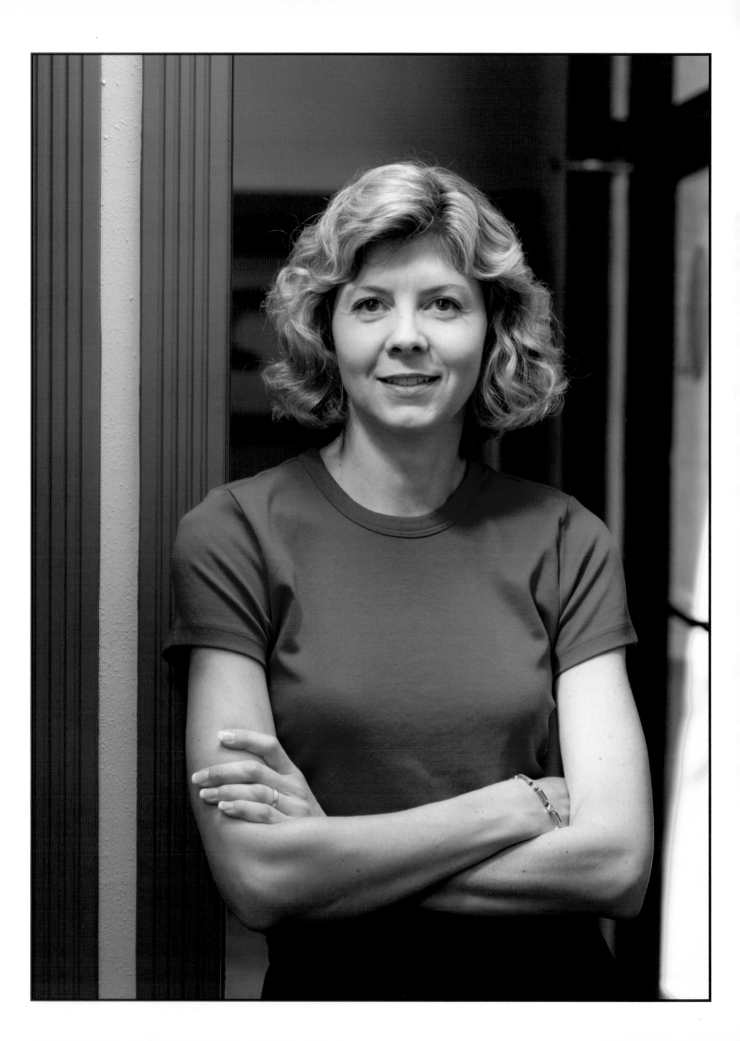

# Payne Financial Group

CAMERA: Hasselblad H3D

LENS: 120mm macro

ISO: 50

EXPOSURE: f/6.8 at 1/15 second

LIGHTING: Profoto 800ws pack powering a 30-degree grid as main light and a medium Plume softbox place behind the first light; white reflector for fill

### Assignment

I was assigned to photograph a series of portraits of employees of the Payne Financial Group, an insurance company, for billboard advertising.

### Visual Objective

The ad agency wanted something very stylized that would look good in black & white.

### Pose

I had Angela cross her arms and directly face the camera to show confidence.

### The Story

When I learned that these images would be used for billboards, a red flag went up. I had been using my Canon D30 for commercial work, but the resolution would not hold up for billboard-size work. The client preferred that I shoot digital and approved the funds to rent a Hasselblad H3D 39 (list price $29,000). So I was embarking on a shooting a big ad campaign with a camera I had never used before. Yikes.

The camera arrived on a Friday and I spent the weekend getting comfortable with it and the software. On Monday, my assistant and I set up on location for the Tuesday shoot. Before we left, I tethered the camera to my laptop for a test shot. All was well.

The next morning, however, I tethered to the computer for another test shot and the camera froze. My

heart started racing and I figured I'd try rebooting. Presto! I was back in business.

It turned out to be a three-day shoot—and about 30 gigabytes of images. (*Note:* I ended up asking the client for 500-gigabyte external hard drive so I could download the images and deliver it to them.) The quality and sharpness of the images was phenomenal and the client was thrilled. Two weeks later, images started appearing on billboards around the Northwest.

### Tips

I am fanatic about backing up my digital files after the shoot. I download the images from my card to my computer's hard drive, then drag my files to an external hard drive for additional back up. You can never have too much memory.

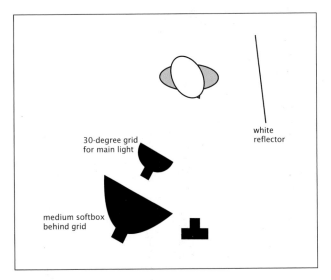

30-degree grid for main light

white reflector

medium softbox behind grid

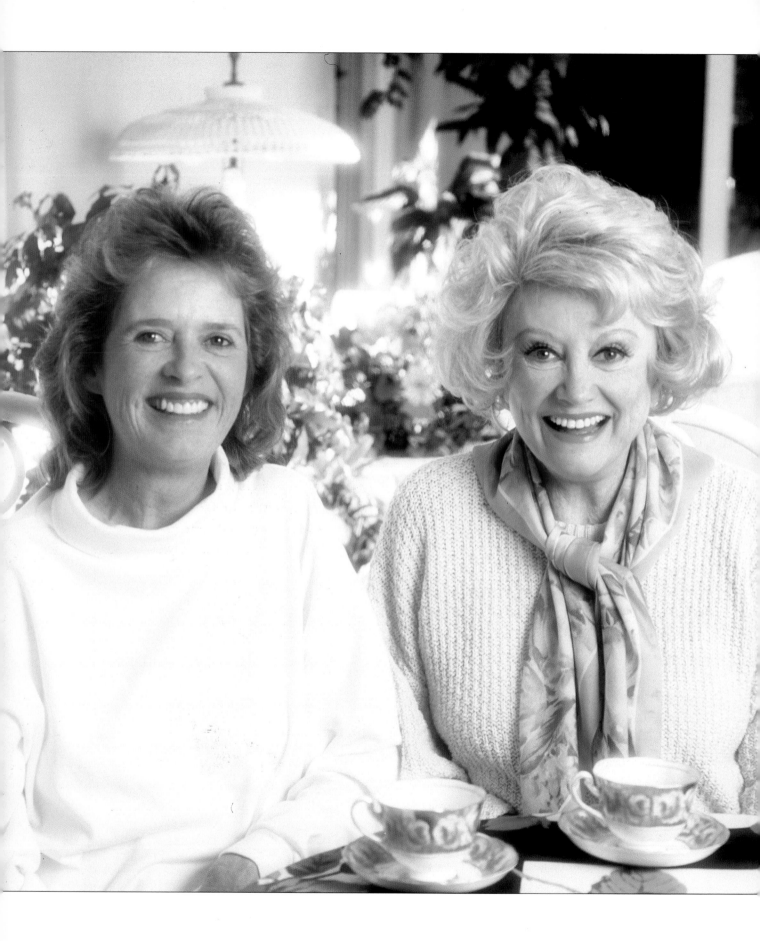

# Tea Time

**CAMERA:** Hasselblad 500cw
**LENS:** 120mm macro
**FILM:** Fuji RDP
**EXPOSURE:** f/5.6 at ¹/₆₀ second
**LIGHTING:** Profoto 800ws pack with a medium Plume softbox
**OTHER:** Softar II filter

### Assignment

I photographed Phyllis Diller with one her daughters for my "mothers and daughters" project.

### Visual Objective

I wanted to create a scenario that would depict a moment a mother and daughter might have together.

### The Pose

I set up a little tea party for Ms. Diller and her daughter Stephanie to attend. I wanted to position them as if someone had just walked in on their conversation.

### Story

My assistant (my wife Kate) and I arrived at Ms. Diller's home in Brentwood. As she showed us around her home, I began to look for locations to take two portraits (as part of the agreement, I was to photograph Ms. Diller with her two daughters separately).

The first set-up (not shown) was in her lavishly decorated bedroom. I wanted the other setup to be very different, and found the spot when I saw an outdoor patio that reminded me a French café. The dominant colors were white and pink so we set up the table accordingly. They were delighted with the setup and started sipping tea and chatting. I got their attention from time to time with some of my inane jokes.

At the day's end, Ms. Diller gave us one of her signed books: *Phyllis Diller's Marriage Manual.*

### Tips

Styling can be just as important as the lighting, especially when you are visualizing your shot. Sometimes it is a matter of looking around the environment to see what you can use to complement the look. Other times, you may have to bring in your own props.

Think about color, wardrobe, and texture when propping a shot. In this image, it was all about color for me. I made sure I stayed within the pink, white, and green motif. By creating a repetitive pattern of color, the emphasis transfers to your subject. Isn't that the primary objective of a good portrait?

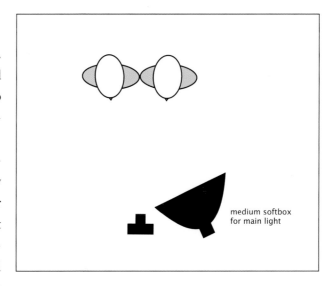

medium softbox for main light

CASE STUDY #50

# Hangin' with Hal

**CAMERA:** Hasselblad 503c

**LENS:** 120mm macro

**FILM:** Fuji RDP

**EXPOSURE:** f/8 at ¹/₁₅ second

**LIGHTING:** Luz 800ws pack with spun glass on 40-degree grid for main light (black wrap used as gobo to prevent spill on background); Luz 800ws pack with 20-degree grid and black-wrap gobo on background

### Assignment

*Us* magazine assigned me to photograph Hal Gurney, the director of the *David Letterman Show,* at work.

### Visual Objective

I wanted to capture a moment of quiet in the busy schedule of a television director.

### Pose

I basically let Mr. Gurney do his thing, pointing his finger, talking on the microphone and so on. I finally asked him if he could take a quick break to sit back and try and look relaxed. He did, and I took the shot.

### Story

I arrived early to scout the location. When I went into the control room, I saw monitors displaying Letterman on the set and decided that was going to be my background. After I had the union electrician plug in my strobe packs, I began to set up my lights. (*Note:* As an independent contractor shooting on a television set, anytime you want to plug in, you have to ask the union electrician to do it for you.) I took some Polaroids of my assistant sitting in Hal's chair and noticed some reflections from my main light on the monitors. Just as we placed black wrap around the light, Mr. Gurney walked in and said he was ready—meaning he did not have much time.

I shot one more Polaroid, switched to film, and just starting shooting. I asked my assistant to peel the Polaroid when it was ready and let me know if we got rid of the glare.

### Tips

When photographing in a populated area, tape down your cords and stands. I also tape down the feet of the light stands to prevent them from being knocked over.

Also, when photographing monitors, be sure your shutter is ¹/₃₀ second or slower to avoid a pattern that will appear if you shoot at a faster shutter speed.

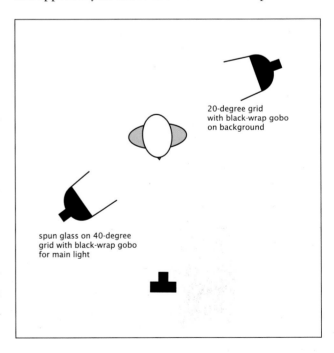

20-degree grid with black-wrap gobo on background

spun glass on 40-degree grid with black-wrap gobo for main light

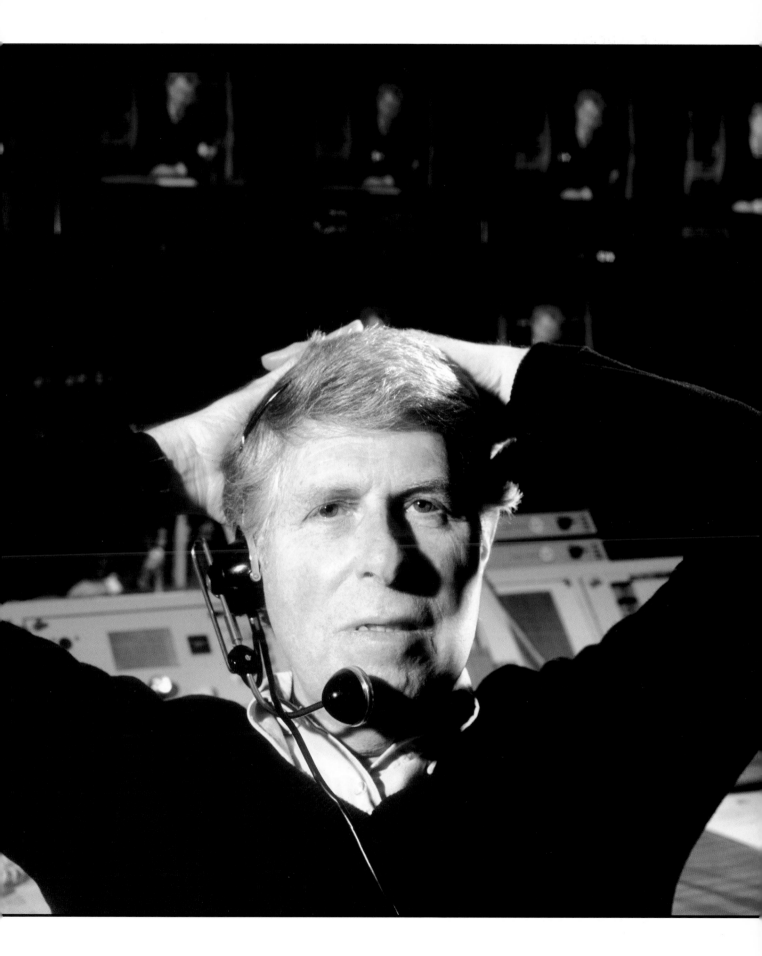

# Conclusion

After shooting professionally for over twenty-five years, I have found that it never gets old. I am always facing new challenges, always thinking about new ways to market my business, and challenging myself creatively. It hasn't been easy sustaining a profitable business, but the time spent trying has always been well worth the effort.

As a portrait photographer I have had the privilege to meet fascinating people and work with very talented creatives. The great thing about this profession is that I never plan to retire from the field. I plan to continue to create photographs, write about photography, and teach photography.

I say all this not to inflate my ego but to inspire you to follow your photographic desires. It is not always easy to sustain yourself as a professional portrait photographer, but if you have the desire, determination, and staying power, it will be well worth the journey.

*I am always facing new challenges, always thinking about new ways to market my business . . .*

Each big journey starts with a first step. I hope this book will give you some insight, practical information, and inspiration to begin or continue on your path to a life-long profession of creating.

# Index

## THE ART OF COLOR INFRARED PHOTOGRAPHY

*Steven H. Begleiter*

Color infrared photography will open the doors to a new and exciting photographic world. This book shows readers how to previsualize the scene and get the results they want. $29.95 list, 8.5x11, 128p, 80 color photos, order no. 1728.

## THE PORTRAIT BOOK
### A GUIDE FOR PHOTOGRAPHERS

*Steven H. Begleiter*

A comprehensive textbook for those getting started in professional portrait photography. Covers every aspect from designing an image to executing the shoot. $29.95 list, 8.5x11, 128p, 130 color images, index, order no. 1767.

MONTE ZUCKER'S
## PORTRAIT PHOTOGRAPHY HANDBOOK

Acclaimed portrait photographer Monte Zucker takes you behind the scenes and shows you how to create a "Monte Portrait." Covers techniques for both studio and location shoots. $34.95 list, 8.5x11, 128p, 200 color photos, index, order no. 1846.

## SIMPLE LIGHTING TECHNIQUES
### FOR PORTRAIT PHOTOGRAPHERS

*Bill Hurter*

Make complicated lighting setups a thing of the past. In this book, you'll learn how to streamline your lighting for more efficient shoots and more natural-looking portraits. $34.95 list, 8.5x11, 128p, 175 color images, index, order no. 1864.

THE SANDY PUC' GUIDE TO
## CHILDREN'S PORTRAIT PHOTOGRAPHY

Learn how Puc' handles every client interaction and session for priceless portraits, the ultimate client experience, and maximum profits. $34.95 list, 8.5x11, 128p, 180 color images, index, order no. 1859.

## MINIMALIST LIGHTING
PROFESSIONAL TECHNIQUES FOR LOCATION PHOTOGRAPHY

*Kirk Tuck*

Use small, computerized, battery-operated flash units and lightweight accessories to get the top-quality results you want on location! $34.95 list, 8.5x11, 128p, 175 color images and diagrams, index, order no. 1860.

## JEFF SMITH'S POSING TECHNIQUES FOR LOCATION PORTRAIT PHOTOGRAPHY

Use architectural and natural elements to support the pose, maximize the flow of the session, and create refined, artful poses for individual subjects and groups—indoors or out. $34.95 list, 8.5x11, 128p, 150 color photos, index, order no. 1851.

## BEGINNER'S GUIDE TO PHOTOGRAPHIC LIGHTING

*Don Marr*

Create high-impact photographs of any subject with Marr's simple techniques. From edgy and dynamic to subdued and natural, this book will show you how to get the myriad effects you're after. $34.95 list, 8.5x11, 128p, 150 color photos, index, order no. 1785.

## MASTER LIGHTING GUIDE
FOR WEDDING PHOTOGRAPHERS

*Bill Hurter*

Capture perfect lighting quickly and easily at the ceremony and reception—indoors and out. Includes tips from the pros for lighting individuals, couples, and groups. $34.95 list, 8.5x11, 128p, 200 color photos, index, order no. 1852.

## THE BEST OF PHOTOGRAPHIC LIGHTING 2nd Ed.

*Bill Hurter*

Top pros reveal the secrets behind their studio, location, and outdoor lighting strategies. Packed with tips for portraits, still lifes, and more. $34.95 list, 8.5x11, 128p, 200 color photos, index, order no. 1849.